Photog
Light

THE EXPANDED GUIDE

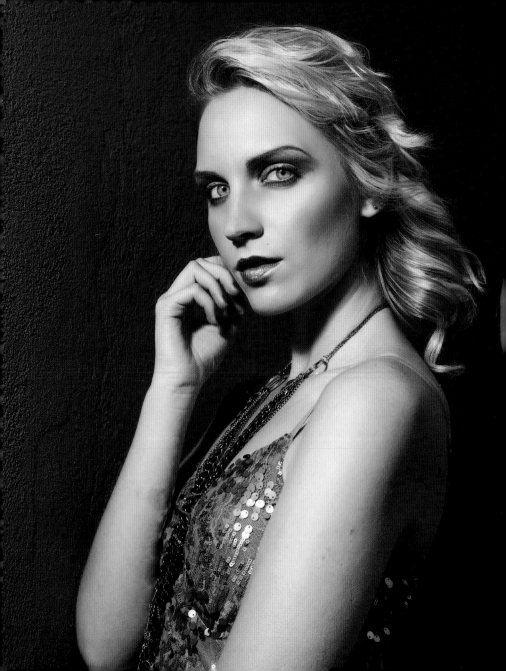

Photographic
Lighting

THE EXPANDED GUIDE

Robert Harrington

AMMONITE
PRESS

First published 2013 by
Ammonite Press
an imprint of AE Publications Ltd
166 High Street, Lewes, East Sussex, BN7 1XU, United Kingdom

ISBN 978-1-90770-875-6

Series Editor: Richard Wiles
Design: Richard Dewing Associates

Typeset in Frutiger
Color reproduction by GMC Reprographics
Printed in China

(Page 2)
Camera: Nikon D3, 50mm lens
ISO 200, 1/160 sec. at f/9.0
Flash: Nikon SB910 at ½ power,
Large Rogue Flashbender

CONTENTS

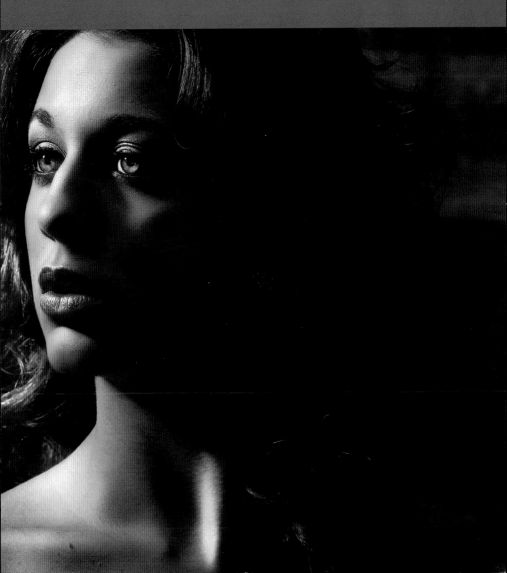

CHAPTER 1　THE BASICS

The basics of flash

One of the most overused yet misunderstood pieces of photographic equipment is the flash. Here's a guide to the fundamentals.

Flash (noun): *a brief, sudden burst of light*
The biggest advantage of the flash that's either built into your camera or an external unit such as a Nikon SB910 or a Canon 600 X-RT is the ability to add light to your images, but the biggest disadvantage is the complex nature of flash that puts many off to using it to its full potential. Understanding the nomenclature, the buttons, and dials on the flash itself, and the menus inside, is akin to trying to learn a foreign language in only a week: it's impossible.

What in the world is FEC? What does TTL mean and how do we use it effectively? What is high-speed synchronization? How are we as photographers, most of us non-engineering-types, going to understand the complexities of these systems and put them to effective use in the field? Picking up a manual full of technical jargon is a daunting task, considering what is

inside is just as confusing as the flash itself. When you purchase your flash, you usually follow something called the "Guide Number." But what is a guide number? Is it related to

ICON IDENTIFIER

Some of the symbols used with flash: you'll need to recognize these and know exactly what they refer to:

 Auto flash bracketing (the same symbol is also used for autoexposure bracketing)

 Flash compensation control

 Flash off (overrides the automatic flash)

 Flash on or **flash ready**

 Red-eye reduction mode (uses preflash to minimize red-eye).

REAR **Rear curtain synchronization**

SLOW **Slow curtain synchronization**

subject distance responding to flash output, shutter speed, aperture, and ISO, or is it just a number that gives us a total flash power rating? That's the problem. As modern-day photographers used to picking up a camera and having it do all the work for us, some of the foundations that are used to build a good technical understanding of photography have gone to the wayside. How are we to understand what a "Guide Number" is if we've never had to deal with the concept?

The automation of photography is one of the greatest gifts in photography. Now, anyone can pick up any kind of camera and capture a great image. Along with computer software, even the worst image we've ever taken can be turned into art, worthy of a gallery or the wall of your home. But we really need the lessons of the past to understand the current trends in flash photography, so we can fully begin to understand the flash on or off our cameras.

Let's jump right in here and look at the basics of flash. Let's try to understand the concepts and numbers that cloud our thoughts, and see how we can get great images without spending an excessive amount of time in software: you may find that you're trying to fix images you could have captured properly in the first place.

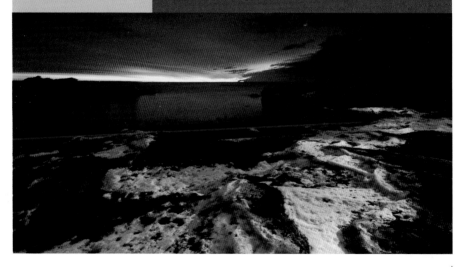

WIDE-ANGLE LENS

Nikon D200, 12–24mm lens, ISO 100, 13 sec. at f/13 Nikon SB800 with Nikon SC29 flash cord attached

A wide-angle lens was used here capture foreground and background simultaneously. The image foreground was brightened by using on camera flash attached to my camera by a flash cord. I set my exposure and used the TTL selection on my flash to get it near the ground and light the snowy rocks separately from the rest of the exposure.

Guide numbers

First, let's look at "guide numbers." In the old days, in those photos where you see a press photographer holding an ancient Graflex camera with a bulb flash on the side, the photographer had to figure out subject-to-camera distance in order to set a shutter speed and aperture to capture an image his editor would accept for the next edition of the paper. So think about what is going through the photographer's head. In the amount of time it took to read this passage, the photographer figured it all out, set his camera and took a shot, replaced his flash bulb and film, and got ready for another shot: Whew!

As modern-day photographers, we need not concern ourselves with figuring all of that out—or do we? Understanding how guide numbers work will give us a greater understanding of how our flashes work and in what situations. To find the right guide number for your flash situation, you need only to look at simple math:

Guide Number = Distance x Aperture

Initial guide number calculations are based on an ISO of 100. As in all things in photography, if you change the aperture, distance, or ISO up or down the guide number will change reciprocally. But you need to find this initial starting point to figure that out. So if your subject distance is, say, 10ft (3m) and your aperture is f/5.6, then the guide number on your flash should be 56ft (17m) with your flash on full power, using all the power accessible to you. If you stop your aperture down, say, to f/8, then your distance halves to 28ft (8.5m). This

is, of course, if you are working with the flash at full power. If you halve the power, then the distance, just like stopping the aperture down, halves to about 14ft (4.25m). These calculations are all based on using your flash with a bare head. The numbers will be affected by a great many variables, including putting a diffuser over the flash head, using an umbrella, or a softbox.

This does get easier. On the back of some flashes, there should be a Guide Number or GN setting. This takes the guesswork out of guide numbers, if you want to use them. On the back of a Nikon SB910, for instance, the GN setting gives you all the information you need. Set to an ISO of 200, it's base ISO setting, and the GN setting gives you the perfect flash output and subject distance. If I set my camera to Program Automatic, letting the camera choose everything, with a 50mm lens I get an ISO of 200, shutter speed of 1/60 sec., and an aperture of f/5. At these settings the flash will automatically tell me that my optimal camera-to-subject distance

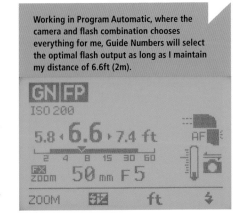

Working in Program Automatic, where the camera and flash combination chooses everything for me, Guide Numbers will select the optimal flash output as long as I maintain my distance of 6.6ft (2m).

is 6.6ft (2m) with automatically adjusted flash output of between 5.8ft (1.77m) to 7.4ft (2.25m). In this mode, the camera will do everything for me.

If I swap settings and go to Manual Mode on my camera using the same 50mm lens and choose ISO 200, shutter speed 1/125 sec., and an aperture of f/8, the GN setting on the flash will automatically tell me the camera-to-subject distance of 6.6ft (2m), but the automatically adjusted output for the higher aperture will decrease a little and have an adjusted GN distance of 5ft (1.5m) to just under 7ft (2.1m). By choosing a faster shutter speed and smaller aperture, the overall distance is reduced a bit.

Guide numbers now have been relegated to the category of overall flash output. If you do a search for a new flash for your kit, you'll be thinking about guide numbers a lot. The guide number of a Nissin Di866 is 198ft (60m) at ISO 100, compared to the Nikon SB910, which is 111.5ft (34m) at ISO 100, or the Canon 600

EX-RT, which is 197ft (60m) at ISO 100. The units differ in overall flash output on the highest end of the guide number spectrum, so depending on your camera system or flash, you can shop using guide numbers as your gauge to the most powerful flash at optimal outputs for your needs.

Working in Program Automatic and TTL, the flash output will vary depending on my distance. The graph now gives me a flash to subject distance of between 2.5 and 40ft (.762–12m). Now, I have the ability to move around, my flash output will change automatically and I don't have to worry about Guide Numbers.

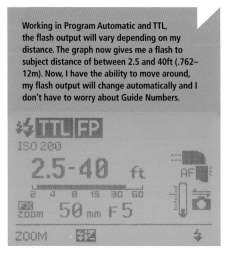

Working in Manual Mode, where I have full control of exposure, with a shutter speed of 1/125 sec. at f/8, the flash will choose a different power output for a 50mm lens at my optimal distance of again 6.6ft (2m).

Through the lens

Now that we've covered the basic and classical way of determining your flash-to-subject distance to obtain your optimal flash output for a correct exposure under perfect conditions, let's take a look at what your flash is capable of without any consideration for the math involved in determining your exposure. Everything that determines exposure on your camera—point and shoot or DSLR—is determined Through The Lens or TTL. The acronym TTL confuses a great deal of novice photographers. Through The Lens

or TTL only means that the camera has the ability to automatically determine exposure by simply seeing the scene in front of it. All this information enters the camera through the lens.

When you point your camera toward something—landscape, seascape, a person, or whatever—the camera can only see the world through the lens. Get used to seeing, saying, and understanding this concept, because once you understand it, your photographic life becomes much easier. When you point your camera toward a subject, whatever that subject may be, you immediately get an exposure reading. Whether or not it is the correct exposure for the scene, or the correct exposure for the creative look you're after, is not the point: the point is that the camera sees the world and then determines all the variables needed for a correct exposure based on that scene.

For flash photography, TTL is based on the same concept. The camera sees the world, sets an exposure for a correct image capture, then tells the flash how much power output it needs to get light to your subject for a correct exposure using the flash. The TTL function automatically performs the Guide Number calculation for you, so while it's important for us as photographers to understand how Guide Numbers work, it becomes less important for us to understand how to employ them in our photography.

TTL is especially suited for on-camera flash. Although there is the use of TTL for off-camera flash while using certain radio triggers or in-camera exposure gauges such as Nikon's Creative Lighting System, we'll begin with on-camera flash.

On-camera TTL

On-camera TTL is a great way to begin to understand your flash. The camera and flash combination will choose everything for you until you decide that the result is less than desirable; then you take the next step into what is termed Flash Exposure Compensation, or FEC. Whether using your built-in popup flash, the flash on your point-and-shoot camera, or a speedlight, you have the ability to control flash output and override the chosen camera settings. FEC is simply controlling the output of your flash through the flash.

The LCD on the back of your camera becomes the most useful tool in determining your image and in creating the look that you desire. Having the ability to see an image right before you instead of having to wait for film development is a huge asset to the digital photographer. You can adjust exposure and light output right from your camera after you determine that your initial test shot needs more or less light or needs to be shot from a different angle, or just needs something more creative.

In the series of images below and overleaf all captured with on-camera popup flash, you can see the difference FEC makes in the image. This is also called "fill flash" and is what you want to achieve when using direct on-camera flash: you don't want to overpower your subjects, just add a touch of light to lift the shadows and add a

fill light, as if using a reflector. TTL-based flash is going to want to add enough light to illuminate your subject(s) completely, so the flash becomes the main light source. However, this may not be what you want in the final image. In this case you have the ability to adjust flash output by entering the flash's menu and adding or subtracting flash power manually.

NATURAL SHADE
Shot in the shade, natural Light gives a soft and flattering light, but your camera tries to expose for the foreground and background evenly, producing slight underexposure.

Nikon D200,
18–70mm lens, ISO 200,
1/125 sec. at f/5.6

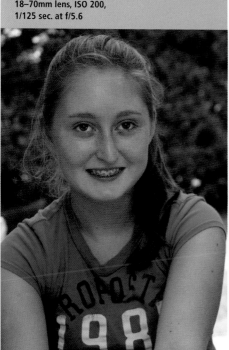

POPUP FLASH
Shot with the camera's popup flash, the subject is brightened while the background maintains the same exposure. The fully automatic on-camera flash did a perfect job of exposing for the foreground and background and at the same time adding light to give a perfect exposure on the subject.

Nikon D200,
18–70 lens, ISO 200,
1/180 sec. at f/4.5

Now that we've seen the effect you can get with a popup flash, let's take a look at the more powerful speedlight. The speedlight allows you multiple choices for how you want to attain your final image. With the speedlight set to TTL, your camera set to Program Auto to keep things simple, and with the head pointed directly toward your subject, you get a clean

Here the camera overexposed while trying to give me good results on the foreground and background.

Nikon D3, 70–200mm lens,
ISO 200, 1/200 sec. at f/20,
Nikon SB910 flash at even exposure

Here, by adjusting my FEC down by -2/3 of a stop of flash output, the camera gave me something with a more even exposure for background and foreground.

Nikon D3, 70–200mm lens,
ISO 200, 1/200 sec. at f/20,
Nikon SB910 flash at $-2/3$ flash exposure compensation

and well-exposed image according to what the camera sees. As the camera will always give you a correct exposure for the scene, it's important to note that what the camera gives you isn't always the best result.

But by simply using one control, Flash Exposure Compensation, you can adjust flash output for a desired result. FEC sounds like a complicated acronym holding inside of it a large and difficult series of changes to your flash, but in reality all it means is that you change the output of your flash to determine how much light you want on your subject. FEC is truly a simple concept that gets overlooked by many photographers, especially beginners, due to the fact that most of us are not engineers and camera and flash manuals are not written with us in mind. They are also written as though you have a full understanding of your flash and they simply spell out the instructions on where the buttons are and how to push them.

In the photo, far left, direct flash was employed. As you can see the camera wanted to give me a correct exposure all around. Not wanting to overpower my subject with a huge blast of flash, the remedy was to simply drop my FEC or just, in layman's terms, drop the power down on my flash so the subject was not overblown or washed out with light. By adjusting my flash power down -$^2/_3$ of a stop, I was able to add fill light to my subject without destroying her skin. At this point, I've used FEC simply and effectively to get a better end result in my photo.

Inverse square law and exposure

Let's move to one of the staples of basic lighting technique: the inverse square law. This principle will be applied later as we move into off-camera flash and light placement. But for now we'll touch on the subject here so you begin to understand light and its relative distance-to-subject ratios in order to get great results with your flash.

The inverse square law states that "..the intensity of the light source is inversely proportional to the square of the distance from the source of light." Basically what this means is that the further your subject is from your flash, the lower the amount of flash is going to reach them. So if you are at full power using direct flash and your subject is approximately 3ft (1m) from you, you'd need an aperture of f/16; if your subject moved back to 6ft (2m) away from you, you'd need an aperture of f/8; and if your subject moved 9ft (3m) away from you, you'd need an aperture of f/4 in order to capture enough light from your flash to illuminate your subject.

As your subject moves farther and farther away from you, the amount of flash power reaching it is diminished. The most noticeable place you'll find the inverse square law in action is in low light, when you are unable to get enough flash power to your subject and the background goes dark. As your subject moves away from you, the flash just doesn't have enough power to fully light the entire scene.

Modern digital cameras can combat the problem caused by the inverse square law in a number of ways:

1) Increasing the camera's ISO will increase the sensor's sensitivity to ambient light and increase the amount of background (ambient) light affecting the exposure.

2) Exposure can be controlled manually. Instead of relying on the camera, take a test shot in Program Auto and check the results on the LCD screen. Then, switch to Manual Mode where you can adjust shutter speed and/or aperture to let more light in, thereby increasing the exposure and allowing the flash to work less hard.

For example, if the camera suggests an exposure of 1/60 sec. at f/5.6 (ISO 400) when it's set to Program Auto, switch to Manual Mode and set the shutter speed to 1/30 sec. and the aperture to f/4. This will increase the exposure by two full stops, making it easier for your flash to light your subject.

The inverse square law comes into play more when we begin to explore off-camera flash and lighting placement, especially with main light placement. This is an important concept to grasp. As we move farther along, we'll be seeing the effect of the inverse square law. Lighting placement is a direct result of our understanding of how light hits our subjects from the front, rear, and sides when using on- or off-camera flash. But the inverse square law also helps us to understand exposure and how to adjust our exposure. If we photograph our subject at 6ft (2m) away at 1/60 sec. at f/8 and then move back another 3ft (1m) to 9ft (3m)

then we know we can immediately adjust for at least a one stop difference in exposure from f/8 to f/5.6 to start. The one stop difference may not be enough—we may need to adjust to f/4—but the idea is to begin understanding how lighting on our subject is affected by distance.

The inverse square law is directly linked to exposure. If we need to place our light somewhere, we need to understand how that light interacts with our subjects for shadow and fall off and all things related to light placement. We also need to understand how to expose properly for the light hitting the subject. The best way to learn this is to use your camera as a guide:

1) Set a scene in which to shoot a still life.

2) Use a tripod so you can move around the scene to see what is happening.

3) Set your camera to Program Auto and see what the camera chooses for shutter and aperture and jot that down on a piece of paper.

4) Then go to Manual Mode and set shutter and aperture manually. Once you've done this, you can completely control the camera.

5) Take a shot, view the LCD and Histogram, and go from there.

6) Next, put a flash on your camera and do the same thing over and over till you begin to understand how it works. Once you've got it, you've got it!

7) Finally, play with the inverse square law and keep your settings the same but move your subject farther away and see how it darkens as not enough light is hitting it, then you readjust your shutter, aperture, or ISO to get a good exposure.

Notice previously I said, "good exposure." There are no perfect exposures. You can read the histogram up and down, to the right or left, it doesn't matter. There are two aspects to exposure that you can see right on your camera's LCD: the Histogram and Highlight Clipping or "blinkies" as it is often called.

The Histogram represents exposure. The perfect histogram would touch the left, or black, side and continue in what looks like a mountain range till it touched the right, or white, side of the graph. It is literally a bar graph that helps you decipher what is going in you exposure. The histogram is designed to tell you where

HIGHLIGHT CLIPPING
Highlight clipping is when your image loses detail. The red blotches all signal that pixels are missing in the image. Digital photography differs from film in that film handled the highlights, or bright areas, better than digital. Modern sensors are getting better at handling the highlights but you should try to avoid highlight clipping.

Nikon D3, 70–200mm f/2.8 VR lens, ISO 400, 1/60 sec. at f/5.0

CLIPPING CORRECTION
Software programs like Capture One, Aperture, Lightroom, Adobe Camera Raw, Photoshop, and others have adjustment controls to bring back the highlights if they are not completely destroyed. Minimal highlight clipping can be repaired by using the controls in your software. This image was corrected in Capture One Pro 6 using the Dynamic Range Slider.

Nikon D3, 70–200mm f/2.8 VR lens, ISO 400, 1/60 sec. at f/5.0

FAVORING THE LEFT

Light and shadow play complementary roles in creating an effective image. Pay attention to the histogram for exposure. Here it favors the black, or left side of the histogram as the dominant tone is black. There are no perfect exposures, just your creative vision.

Nikon D3, 70–200mm f/2.8 VR lens,
ISO 200,
1/125 sec. at f/5.6

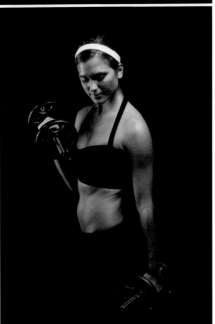

FAVORING THE RIGHT

The image here spikes to the right, as the predominant color tone is white. It is exactly the opposite of the fitness model (left), where the dominant tone is black and the histogram spikes to the left.

Nikon D3, 70–200mm f/2.8 VR lens,
ISO 200,
1/125 sec. at f/5.6

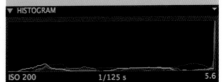

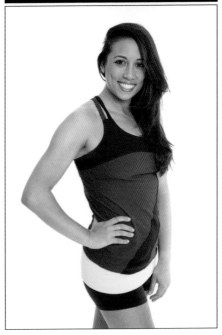

your exposure lies in between the two points of white and black. It is based on the Zone System developed by Ansel Adams. He determined that variations of color tone affect exposure and that these variations can be measured and used to get your exposure.

The second method of assessing exposure is to use "highlight clipping," which can be activated so it is shown on the rear LCD screen while you are viewing your image(s). Commonly called the "blinkies," highlight clipping, or loss of detail, is shown as black (or red) areas that blink on and off. This warning is telling you that you are losing detail or pixels in these areas. However, while it is important to understand exposure values, you also need to learn that you can ignore certain clipped areas in some images.

For portraits, you want to avoid clipping at all cost on the face and skin. If you lose detail in the skin—cheeks, forehead, or nose—it is impossible to repair without spending hours in Photoshop rebuilding those areas. But clipping is less important in backgrounds, so if you have a perfectly exposed image in the foreground, but a blinking highlight in the background sky or through a window, blinkies become less important: your main subject is well exposed, and the background is just there for interest.

Assessment
The histogram is an important tool for achieving a correct exposure. In both of the images opposite the histogram favors one side or the other, so is there one perfect histogram? No. It's the look of the final image that should determine exposure.

NEARLY PERFECT HISTOGRAM
The perfect histogram doesn't exist but we can get close when an image has nearly equal tones from light to dark. Here, the histogram rises from the left due to the dark blue dress, it rises in the middle as her skin represents the mid tone, and it rises on the right from the white background. We can strive to get a perfect exposure/histogram, but we shouldn't let a less-than-perfect one diminish our creativity.

**Nikon D3, 50mm f/1.8 lens,
ISO 200,
1/125 sec. at f/5.6**

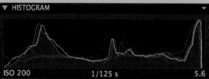

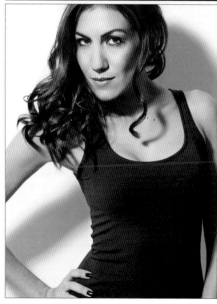

White balance

White balance is the color temperature of light without heat. This can be a confusing concept in the digital photographer's world: how can something be hot or cold but not emit a sensory element? White balance refers to the temperature of light only: there is no hot or cold element to be felt; it is only seen. The correct white balance for any scene is based on your artistic license as the photographer. Do you want perfect white balance with neutral whites and perfect color, do you want something a bit warmer in overall tone, or cooler, or do you want something that balances foreground and background lighting, or a color temperature that is completely creative and tones an image to either side of the spectrum for an artistic effect? White balance allows you full color control creativity in your final image.

Color temperature is measured on the Kelvin scale. Developed by Lord Kelvin in the mid-19th century as a way to give a numerical value to light in order to conduct scientific experiments, it has become a key element in television, video, film, and digital photography, and any medium using these technologies. Lord Kelvin used a "black body radiator," which is an object that doesn't reflect light or allow any light to pass through it, but will show heat as a matter of color. Black body radiators don't produce visible light, but they will glow when heat is applied. Think of a blacksmith. The blacksmith heats a piece of black iron to hammer it on an anvil until it takes a shape. The heat transfer from the fire to the metal in the beginning is warm then as it gets hot to the point of being malleable, the iron turns white hot, at which time the blacksmith can work the metal into any shape. The yellows and oranges in the beginning of the heating process are cool temperatures. The hotter temperatures are now white as the metal is heated to the point where it literally turns white and is now so hot it can be formed.

White balance temperatures follow along

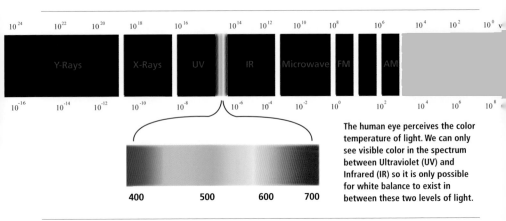

The human eye perceives the color temperature of light. We can only see visible color in the spectrum between Ultraviolet (UV) and Infrared (IR) so it is only possible for white balance to exist in between these two levels of light.

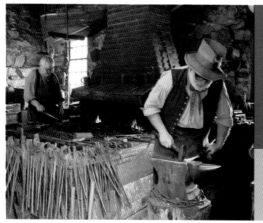

WHITE HOT
Take a look at the hot iron the blacksmith is working on the anvil. It is nearly white hot or in the color temperature range of about 8000K as shown in the graph below. But if you look at the fire in the pit, you'll see that it is orange and at a temperature of about 1000K as shown in the graph as well and represents a cooler temperature on the scale. The color is warmer but the temperature is cooler.

Nikon D200,
17–55mm f/2.8 lens,
ISO 400,
1/20 sec. at f/2.8

COLOR TEMPERATURE SCALE

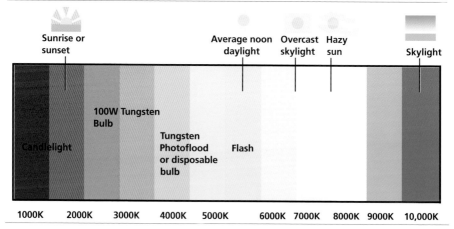

the color tone of the scene, such as the warm light of a sunrise or sunset, the cool light of a sunny day, or the coldness of the atmosphere's scattered light. There are no set temperatures that act as cure-alls to your white balance choice. The sunrise at 6:00 a.m. may be around 2500K, but shortly after at 7:00 a.m., it will change to maybe 3500K. Midday sun is approximately 5000–5500K, which coincidentally matches the output of your flash. The hazy sunlight of an overcast day may reach a temperature of 8000K, then the scattered light particles of the atmosphere may reach and exceed 10,000K and be pure white.

Auto white balance

There are several ways to establish white balance in your camera. Auto white balance (AWB) selects the best average of the light tones in the scene in front of your camera, relying on TTL information that the camera senses. AWB is usually quite accurate. It will take into account all of the lighting colors in the scene and then ascribe a numerical value in degrees Kelvin to your photograph. If you have a scene that has tungsten lighting, such as the lighting in your home, then AWB will choose a color temperature to ensure good overall color in the range of 2800–3200K. This selection will give you good overall color tone and neutral whites and grays. If you are outside on a sunny day, AWB will probably choose something in the neighborhood of 5500K; on a cloudy or hazy day it will choose a value of around 8000K. Remember that all of these are averages and that perfect white balance becomes a creative choice rather than letting the camera choose for you.

Beyond AWB, you have a few other choices for setting white balance. You can select a symbol from the white balance selections in

CORRECT WB: 4000K	TUNGSTEN: 3000K	DAYLIGHT: 5000K

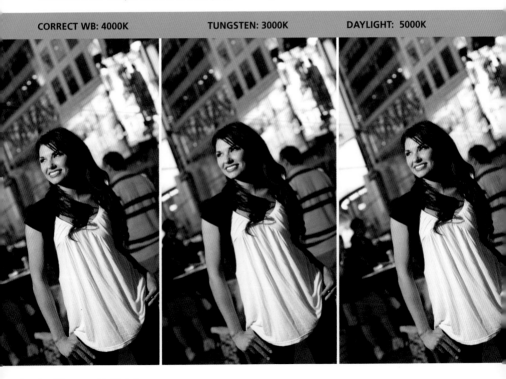

your camera. If you're in broad daylight, you can override AWB by selecting Daylight or Direct Sunlight; if you're in an church, select tungsten or incandescent from the menu to closely match the warm lighting usually associated with theses spaces; if you're in a gymnasium, you can choose the fluorescent setting since most of these spaces are lit with either fluorescent or sodium lighting of around 4500K.

Once you get a feel for color tone and how it is represented with light and temperature based on the Kelvin scale, you can also use the K setting in the camera menu and choose a numerical value. If you're in the gymnasium and choose the fluorescent icon for the white balance, take a test shot and check the LCD screen. If the image is too green, you can adjust the white balance manually, perhaps to 4000K for a better result.

You have a broad range of adjustability within the camera to get a great result.

There is also the Custom White Balance setting you can use to match the scene in front of you. There are several tools on the market that can help to determine correct white balance. One is an 18% Gray card *(below left)*. Note that there is also an 18% gray card inside the front cover of this book.

Other useful gadgets include the Expodisc *(see below)* or the X-Rite Color Checker Passport *(see overleaf)*, which is a pocket-sized variation of the Munsell Color Target used for many years by the television industry to set correct color temperatures for studio and field cameras.

EXPODISC
The Expodisc is a white balance tool that sets a custom white balance in your camera. Place the disc over your camera lens, point it to the main light source (outdoors choose the sun or sky, for off-camera flash or strobe choose the main or key light, for on-camera flash point it to your subject or wall you're bouncing off), and then take a custom white balance reference shot.

18% GRAY CARD
Place the gray card in front of your subject and use the custom white balance function in your camera to set a white balance to match your lighting. Add a cross to enable focusing in any light.

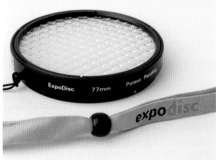

RAW adjustment

Shooting in RAW format is one of the best ways to have creative control over your final image. RAW files capture the most detail and information to create your final image. Unlike JPEGs, which lock in all the exposure information and lose some image quality in the process, RAW files retain all of the information of your capture and offer you the

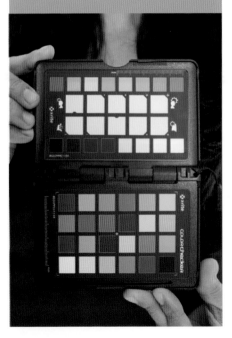

X RITE COLOR CHECKER PASSPORT
The X Rite Color Checker Passport is a white balance and color correction tool based on the Munsell Color Target used in film and TV for years. It is ideally suited to digital photography and allows you to correct for white balance and individual colors.

ability to create multiple files from just one master file and make any changes you want, including white balance, without ever affecting the original file. There is a white balance adjustment tool in most software programs that lets you click on an area of neutral gray or white instantly correct your white balance. Then you can adjust the file from there. If you don't like your final output, then just go back to the original file, make your new adjustments, and then process a new JPEG. This makes capturing your images easier but more time consuming later.

With RAW capture, you'll need a software program to convert your files to JPEGs for print and web output. Your time in front of your computer is therefore increased. Is it worth it? Absolutely! While the debate continues in many digital photography forums about the benefit of JPEG speed compared to the size of RAW files and the time needed to process them and the extra hard drive space needed to store them, RAW format gives you the greatest creative flexibility and must be considered.

As an example, in the image above right, I set the white balance in camera to 3500K for the yellow lights and yellow walls. I put a ½ CTS (Color Temperature Straw) gel on my SB900 flash and bounced the flash around the room (more on bounce flash later). The yellow tone of the walls severely colored the image yellow, which misrepresented the skin tones and the bride's beautiful white dress. In software, all I had to do was get the white balance dropper and click on the bride's dress to achieve perfect color tone in my final result.

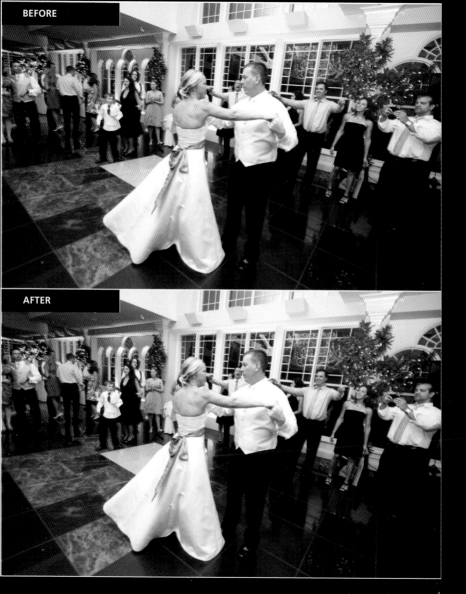

BEFORE

AFTER

Using gels

Gels offer the digital photographer the ability to correct for mixed lighting conditions or to add color creatively. For instance, in the case of shooting in a situation like a wedding, the lighting is usually warm candlelight or tungsten-based light, which is around 3200K, but your flash is based on about 5500K. There is a large color temperature difference, so we use gels to correct for this difference. By putting a Color Temperature Orange (CTO) gel on the flash, it is balanced to the existing or ambient light. However, if you're feeling creative, you can add different colored gels to add mystery or any amount of creativity.

THE ROGUE UNIVERSAL GEL KIT
These gels are precut to fit any flash head, and the kit comes with a thick elastic for easy and secure attachment. Each gel is marked with its color and corresponding light transmission rate, which tells you how much light it uses.

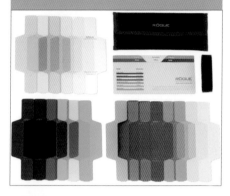

Nikon D3, 70–200mm f/2.8 VR lens, ISO 200, 1/125 sec. at f/3.2

COLOR MANIPULATION
Place gels on your flashes to dramatically alter the look of your images. You can use gels for color enhancement or for color correction while shooting under mixed lighting conditions.

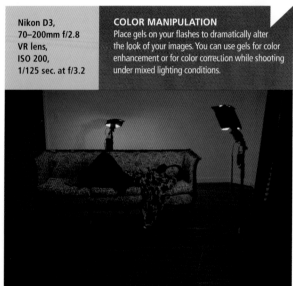

GETTING CREATIVE *(Opposite)*
Get creative with gels. Set the white balance in your camera to Daylight or take a custom WB before you add a gel, so you capture proper color first before enhancing your lighting. This image was shot with an SB910 main light with a Large Rogue Flashbender and diffusion panel with a Special KH Lavender gel; the backlight was an SB800 with Large Rogue Flashbender with diffusion panel and a Bright Red gel (left). I set the main light on my subject and allowed the backlight to bounce off the wall and room for this final result. You have to play with exposure as each gel reduces light output differently, but the final image is creatively colored at capture and not in postproduction—and that is what you should be striving for.

Nikon D3, 70–200mm lens, ISO 200, 1/125 sec. at f/3.2

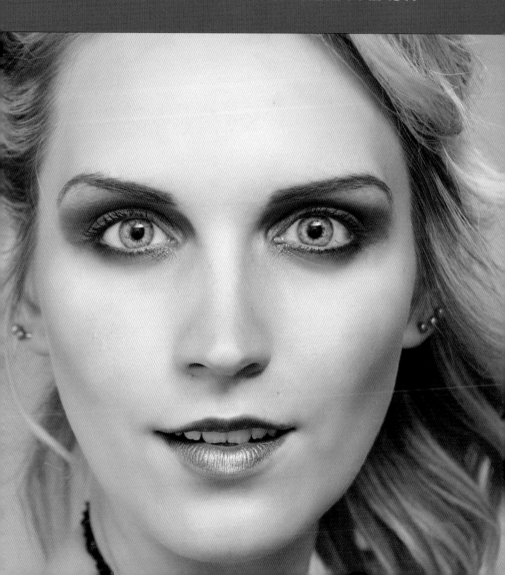

CHAPTER 2 ON-CAMERA FLASH

On-camera flash equipment

The modern day hotshoe flash or "speedlight" is a marvel of technology. It is powerful enough to freeze high-speed action and recharge in a short time to enable us to reuse it without changing a bulb. It enables us to shoot in low light or bright light with shutter synchronization and it allows us the flexibility to adjust the output.

The story of the on-camera flash began in 1931. While trying to find a way to produce stroboscopic light in a small package to freeze moving objects for scientific photography, Harold Edgerton invented the first electronic flash tube. An electrical engineer by profession, Edgerton worked on stroboscopes at the Massachusetts Institute of Technology in an attempt to create a repeating flash fast enough to freeze subjects in motion. A rechargeable tube instead of the flash bulb used in regular photography at the time could be fired in

multiple sequences and freeze action. The tube didn't need replacement after each firing; it was filled with Xenon gas and electronically charged, fired, then recharged for another shot. Harold Edgerton set the stage for the small, powerful flashes available to us today.

FLASH AT THE READY
On-camera flash—either the integral popup (left) or hotshoe unit (right)—allows you to put light into an image, and TTL (through-the-lens) technology gives great creativity without being bogged down by technical aspects.

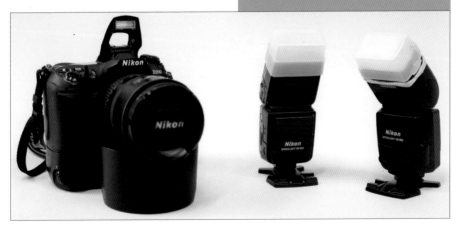

Built-in on-camera flash

The built-in, dedicated flash on your camera allows you to illuminate your subject quickly and easily. It is a convenience that we've become accustomed to on all but the most expensive professional level cameras.

While it isn't particularly powerful, and has a signature look of a short drop shadow and flat light, on-camera flash is still capable of producing great results if used well. The only place these days that you won't see a popup flash is on the top-of-the-line cameras such as the high-end offerings from Nikon and Canon,

and almost all of the medium format cameras made by Mamiya, Phase One, and Hasselblad.

Most on-camera flashes have a guide number of about 40ft/12m (at ISO 100). That isn't a great deal of power compared to the output of an off-camera flash such as the Nikon SB910 (guide number of 111.5ft/34m at ISO 100), but it's perfect for snapshots or grab shots where you only need to add a small amount of light or want to capture that moment in time at a party or family gathering, or any other occasion where the larger flash isn't available. Point-and-shoot cameras are

NATURAL LIGHT
Working on a cloudy day or by moving your subject into the shade gives you soft omnidirectional light that flatters your subject but gives you flatly lit portraits.

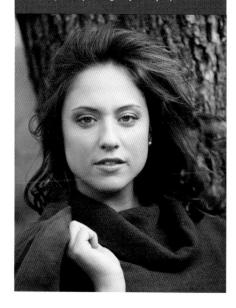

ON-CAMERA FLASH
Create portraits with a completely different look by using on-camera flash, either popup or speedlight, and adding a touch of light to create shadow and drama.

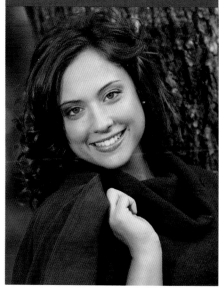

designed with this type of shooting situation in mind and excel at it.

Plus, you have the automation and adjustability of the larger flash at your fingertips. You can adjust flash output, or FEC, or bounce some of the light with a reflector, or add a diffuser to the flash to achieve great soft lighting results. The built-in flash is perfect for adding just a touch of fill flash. But you do have to watch out when using certain lenses; some longer lenses will cast a shadow on the bottom of the image, as the light spread is not high enough off the lens axis to avoid the lens or its hood, if fitted. However, on-camera dedicated flash has its uses and can be effective creatively if used and explored to its fullest.

The hotshoe flash

Unlike the dedicated popup flash, the large hotshoe flash, or "speedlight," is a more powerful and versatile unit. The power range is usually controllable and broader, and the light coverage is larger, meaning that the flash can be used in a multitude of shooting situations. As a result, it has a broader range of applications, including the ability to bounce the flash (both on- and off-camera) or use one or more dedicated off-camera flashes to create sophisticated lighting setups. It can even be mixed with larger and more powerful studio strobe lighting.

The popularity of the hotshoe flash (and, by extension, off-camera flash) has boomed over the course of the last decade as the simplicity, cost effective nature, and overall usefulness of speedlights has grown. This type

of photography is now at the forefront of the photographic medium, allowing entry into areas that were once the preserve of seasoned professional willing to make significant investments in gear. For example, it is now possible to photograph portraits, weddings, and events with a relatively inexpensive speedlight, where an expensive "hammerhead" flash or studio strobes would have been used previously.

NISSIN Di 866
The Nissin Di 866 is a powerful alternative to your manufacturer's flash unit. Coming in at a price point lower than a proprietary flash unit, these third party brands are worth taking a look at, especially since costs can rise exponentially when adding a second, third, or fourth flash to your kit.

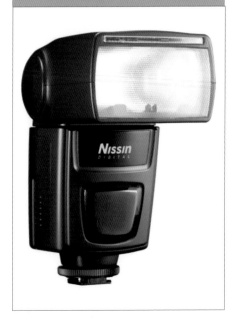

ANATOMY OF A HOTSHOE FLASH

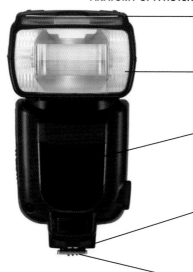

Front

THE NIKON SB910

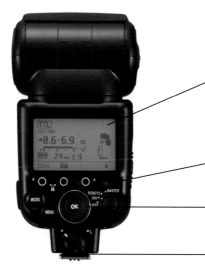

Back

Wide-angle adaptor
Supplementary diffusion panel to increase coverage of the flash to match wide-angle focal lengths.

Diffuser panel
Protects the flash tube, and diffuses the light.

AF illuminator
Provides a patterned light source to aid focusing in low light conditions.

Hotshoe contacts
These make an electrical connection with contacts on the top of the camera. They synchronize the flash with the shutter, and control other "dedicated" features.

Foot
Physical means for connecting the flash to the hotshoe of the camera, ensuring correct alignment of electrical contacts.

LCD Panel
Displays information about flash settings.

Flash ready Light
LED indicator tells you when the capacitor is full, and the flash is ready to fire.

Control buttons
For changing flash settings.

Foot lock
Locks foot onto hotshoe to prevent it slipping off.

Power

With a guide number far exceeding on-camera popup flashes, the hotshoe flash offers greater range and flexibility. It also has two added features: a built-in diffuser panel engineered to accommodate wide-angle lenses that folds over to spread light over a wide area, and a bounce card that can be extended to bounce light around or onto your subject for softer shadows.

Batteries

The larger flash units are able to accept up to four or sometimes five batteries, as in the case of the venerable Nikon SB800, to run

Tip

Add elastic bands to your flashes so you can attach modifiers, bounce cards, or even help a radio trigger stay on with an added touch of security.

the unit. This allows for faster recycle times and more flash output over a longer period. Coupled with fresh batteries, the unit can give a great deal of flashes over an extended period. These units can also accept external battery packs such as those by Quantum,

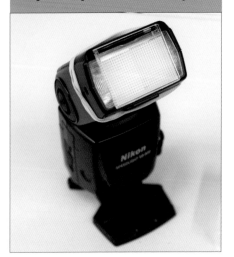

DIFFUSION PANEL
The flip out diffusion panel is used to increase the spread of light when using wide-angle lenses to gain flash coverage over a broad area; however, they also work well to spread light across your image when using direct, diffused flash for fill light.

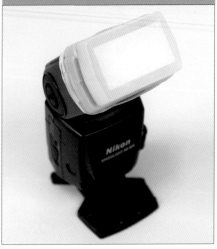

BOUNCE DIFFUSER
The plastic bounce diffuser is a great tool to keep on your flash at all times as it will help to spread and throw light not only up but also around you for soft bounce fill on your subject.

Phottix, or the manufacturer's own brand. Not only does adding multiple batteries to the hotshoe flash give more flashes, but also they allow the flash to recycle almost instantly for longer shooting sessions. It is important to note that, depending on the external pack chosen, the batteries in the flash must be installed to run the mechanics of the flash while the external pack runs the flash head itself.

Battery types

- **Alkaline:** The most popular type, found on store shelves everywhere. Some are high capacity and designed for high discharge electronics, such as flash units.

- **Lithium Ion:** Rechargeable lithium ion batteries are used in most digital cameras because the battery has the ability to be quickly recharged. It is also possible to buy non-rechargeable lithium ion batteries designed for high-drain applications such as hotshoe flashes and some compact cameras.

- **Lithium Polymer:** The successor to the Lithium Ion, with a higher rated recharge rate than its predecessor.

- **Nickel Cadmium:** Older rechargeable cell technology that needed to be discharged before recharging. Battery memory was short requiring more frequent recharging.

- **Nickel Metal Hydride:** Current cell technology that replaces Nickel Cadmium. Excellent recharge rate. Battery memory allows multiple recharges without full discharge; they can be charged many times when coupled with a good charger.

IN-CAMERA SETTING
Nikon's in-camera setting for Commander Mode, or the ability to fire flashes off the camera by using the in-camera settings, is a popular way to activate and control multiple flash units from your camera so you don't need to move and adjust lighting ratios: you do everything from the camera.

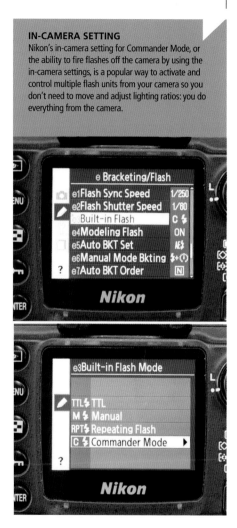

Flash modes

The larger hotshoe flash units also offer mode selection. From TTL to Manual to Guide Number and possibly several other selections depending on the make and model of the flash, the hotshoe flash is ultimately adjustable and can be used in a variety of ways to achieve the desired results.

Flash systems are also available with an infrared facility—such as Nikon's Creative Lighting System (CLS)—which enables them to be used as master or slave flashes in off-camera single light and multiple light situations.

Tilt, swivel, and rotate

The tilt, swivel, and rotating head featured on the larger flash units gives them more flexibility, especially for event photographers wishing to bounce light around a room to achieve pleasing results. At a wedding, for example, it's possible to fill a room with light, illuminating the bride and groom with a soft light, rather than the harsh frontal light of direct flash.

There has been an explosion of modifiers from the simple to the elegant that attach to the flash unit to give great results simply, thereby allowing the photographer to bounce light to the right, left, forward, or even behind to get soft look that in many cases rivals studio lighting fitted with softboxes.

NIGHT PORTRAIT *(Opposite)*
In the top photo, the quality of hard light hitting the model's face is too intense. I asked her to close her eyes so she wouldn't be blinded by the instant blast of flash.

In the second photo, simply by adding a white bounce card, as shown on the right, I was able to bounce light around the room and get a soft fill light to fall on her face, giving me a much better end result.

BLACK AND WHITE BOUNCE
After you've made a bounce card for your flash, be sure to cover one side with black gaffer or any black tape. This way you get white to add some light to your bounce or black to subtract some light from the bounce. Test this on as subject and see the difference. You'll find that it's quite dramatic!

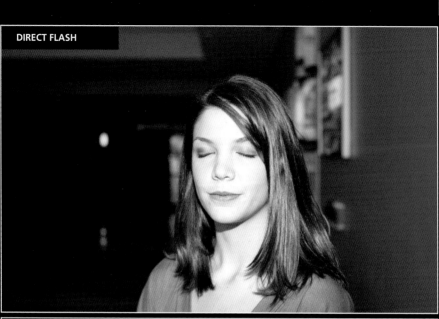

DIRECT FLASH

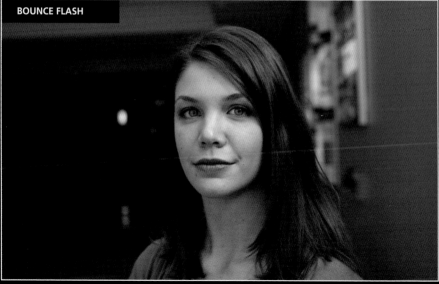

BOUNCE FLASH

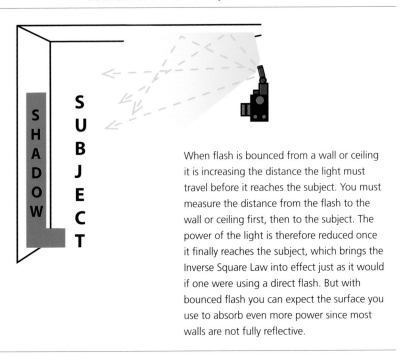

When flash is bounced from a wall or ceiling it is increasing the distance the light must travel before it reaches the subject. You must measure the distance from the flash to the wall or ceiling first, then to the subject. The power of the light is therefore reduced once it finally reaches the subject, which brings the Inverse Square Law into effect just as it would if one were using a direct flash. But with bounced flash you can expect the surface you use to absorb even more power since most walls are not fully reflective.

Getting the angle right

A flash head that rotates or tilts will allow for a wide degree of flexibility when it comes to bouncing flash while still keeping the unit on the hotshoe. Furthermore, wireless or cable-connected flash increases the possibilities of angles to choose from.

You must still decide where to direct the flash in order to get the desired effect. Bouncing the flash off the ceiling is simple. Aim the flash for a point that is closer to the camera than the subject, therefore getting a greater spread over the subject.

Bouncing the flash off a wall, on the other hand, is more difficult since sections of the wall that are overexposed can make their way into the shot because of the spread of the flash. Keep this in mind when composing the shot. Take a test shot so you can check the histogram and highlight clipping indicator to make sure sections of the wall aren't burnt out.

Zoom

Many hotshoe flashes have the ability to be zoomed. While each distance is different per flash unit, the feature allows you to place light over a greater distance, such as in a church or event space with high ceilings. The zoom feature enables you to focus the light and get a tighter spread in a broad area. Some flashes can zoom from 17mm (wide spread) to 200mm (telephoto spread).

Built-in slave

Unlike the systems that are built into the master and slave combination, such as Nikon's CLS, the hotshoe flash also has a built-in slave mode that allows any flash to fire it off-camera. The light detector in the flash registers the other flash firing and then fires at the same time. All of this happens in milliseconds, but the slave allows multiple lights to be fired and multiple systems to be used. A strobe light, for example, can fire a hotshoe flash and vice versa.

Bounce card

Hotshoe flashes also come with a retractable card to add a modicum of forward bounced light onto your subject. Long preferred by photojournalists, the bounce card is a quick and easy way to spread light without having to add or carry a larger light modifier. While the light quality is not the same as a larger card and the light is harder, with deep shadows, the effect is still more pleasing than direct flash.

DIFFUSING THE LIGHT

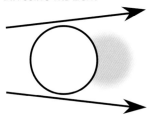

NO EXTRA DIFFUSION
Flash produces hard lighting with distinct shadows.

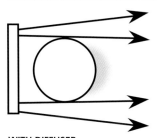

WITH DIFFUSER
Light becomes scattered by the translucent material.

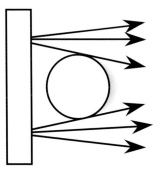

MORE DIFFUSION
The more opaque the diffuser, the greater the light is diffused, but the power is decreased.

Shutter synchronization

One of the greatest benefits we as flash photographers received from Harold Edgerton's invention is flash synchronization. Before his discovery (and subsequent inventions), flash was not synchronized to shutter speed; after Dr Edgerton's research, we have synchronized flash to shutter combinations that allow us to photograph moving targets with our flashes and achieve sharp images. Beyond sharp images, creatively we are given a few options for effects when using flash on or off the camera. We can utilize different configurations for flash

synchronization: front curtain, slow curtain, rear curtain, and high-speed synchronization. But before we go into any of those modes, we need to review how a modern DSLR's shutter synchronization actually works in practice.

Modern DSLRs use what is called a focal plane shutter, which is a pair of shutters or curtains that operate in conjunction with one another to facilitate exposure. When you depress your shutter-release button, the first curtain opens and exposes the sensor; then the second curtain closes to end the exposure and you've captured an image. One of the

IMAGE 1
This image has a shutter speed just below the rated speed of 1/250 sec. for my camera. Notice how it is evenly exposed across the entire frame.

IMAGE 2
I changed the shutter speed to 1/320 sec. or about 1 stop faster than the camera, flash, and radio trigger combination could handle successfully. See how the shutter enters the frame as a dark line.

simplest ways to explain it is to experience it first hand. Place both of your hands with your palms facing flat in front of your chest, then raise one hand over your face to the top of your head, as you just about pass your eyes, raise your second hand to the top of your head so both of your hands meet above your forehead. This is basically the operation of the shutters or curtains in the camera.

Because the curtains travel at a set speed to give you a correct exposure based on aperture and ISO, the second curtain closes the gap faster when a faster shutter speed is chosen, so with

a high shutter speed such as 1/2000 sec., only a small slit of light hits the sensor at any one time to create the exposure.

For flash photography, your camera has a maximum synchronization speed between the amount of time the shutter opens and closes and the blast of flash used to illuminate your subject. The burst flash time for a hotshoe flash is approximately 1/3000 sec., so the speed of the flash must give enough light over time for your exposure. This base shutter speed, sometimes called the X-sync speed, usually maxes out at 1/200–1/250 sec. This allows the shutter or

IMAGE 3
Having changed the shutter once more to 1/500 sec. and about two stops above the rating for camera, flash, and trigger. The black line creeps in even further to begin to completely underexpose the image.

IMAGE 3
Now the shutter is set to 1/1000 sec. or about 3 stops faster than the camera, flash, and radio trigger rating, blocking out the image. The shutter and flash are not synchronizing so I'm getting complete underexposure.

curtains to open, close, and get enough light from the flash to correctly expose your image. As you can see in the images on the previous pages, the faster the shutter speed, the faster the curtain opens and causes the black lines in the image to form. The shutter is going too fast for the flash to shutter synchronization speed.

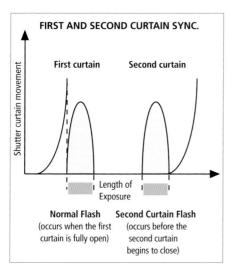

FIRST AND SECOND CURTAIN SYNC.

First curtain Second curtain

Shutter curtain movement

Length of Exposure

Normal Flash (occurs when the first curtain is fully open) **Second Curtain Flash** (occurs before the second curtain begins to close)

First curtain synchronization

First (or front) curtain sync is when the flash fires at the beginning of the exposure. This is the default setting for your flash whether it is popup, built-in, or a speedlight. When the flash fires, it freezes the motion and then the exposure happens after the initial burst of flash. So if your exposure is 1/60 sec. at f/5.6, the flash fires immediately and then the rest of the shutter time, let's say for example 1/59 sec., happens. In this mode, you are nearly always guaranteed a sharp image as the immediate

blast of light stops the action and the rest of the shutter time exists to finish the exposure. The flash fires during the time that both curtains are open so you get a well exposed shot within the X-sync time.

HIGH SPEED SYNCHRONIZATION
Using on-camera high speed synchronization is a great way to get fill flash where you need it. You'll need to set your High Speed Synchronization (HSS) in your specific camera, but once set you'll be able to shoot in bright sunlight and add fill light on your subject successfully.

Nikon D3, 70–200mm f/2.8 VR lens, ISO 200, 1/500 sec. at f/9, SB900 on-camera direct flash using high speed synchronization.

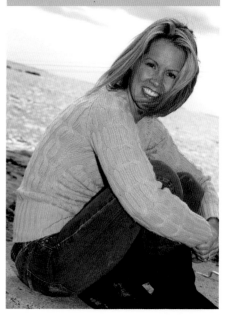

Second curtain synchronization

Second (or rear) curtain synchronization is when the flash fires at the *end* of the exposure, just before the shutter closes. You need to take creative control here and change your flash

setting from front to rear or slow curtain sync (but remember to change it back).

This type of flash photography allows the ambient light to be recorded by your exposure first, and then the flash fires at the end of the shutter time allotted. This technique is also commonly referred to as "slow sync" or "dragging the shutter."

In this instance, more light is let into the camera before the flash fires, so you have the ability to add dimension, depth, and ambient, or existing light to your images. This is especially true if you set a shutter speed of 1/30 sec. or lower. When you set a slower shutter speed, you are allowing the ambient light to reach the sensor for longer, so your final image will have brighter backgrounds. The flash then fires to expose for your main subject, which can create a "motion blur" effect with moving subjects.

High-speed synchronization

High-speed sync, or HSS, allows you to use faster than X-sync speeds to capture images. Your shutter speed is set to exceed the max speed of 1/200 sec. or 1/250 sec. and the flash fires in that shorter time, say 1/500 sec., 1/1000 sec., or even faster. There is a bit of trickery going on to achieve these faster-than-normal shutter speeds. The first change happens in flash duration. You no longer receive an instant burst of flash from your speedlight; you get a series of short bursts that trick the camera into thinking there is enough light to expose properly. HSS is best applied by using the in-camera triggering system, such as the Nikon Creative Lighting System, or using a third party triggering system

REAR CURTAIN SYNCHRONIZATION
Rear or slow curtain synchronization allows the exposure to happen first. In this image, the flash didn't fire till the end of a long exposure, so I was able to zoom my lens and then have the flash fire to freeze my subject. This is also referred to as "dragging the shutter."

Nikon D3, 70–200mm f/2.8 VR lens, ISO 200, 1 sec. at f/5.6

such as the Radio Popper PX or Pocket Wizard Flex. Also, in using HSS, you will need to experiment with light placement. Flash output drops dramatically when HSS is engaged, so when you are shooting, attention must be paid to exposure and flash-to-subject distance. You can compensate in two ways: first, increase the flash power output in TTL mode; second, move the light source closer to the subject and watch your histogram and blinking highlights.

NATURAL ASSETS

Use the sun and your environment to your advantage. Here, by placing my subject in the shade I was able to expose correctly for her face but also use the sun in the background to create a high key effect and let the light streaming through the trees dapple her shoulders and hat. In this case I have two light sources and one of them is free.

LOSS OF POWER

One of the effects of high-speed synchronization is that it affects the guide number of the flash unit. As the shutter speed increases, the effectiveness of the power and the range of the unit decrease. As the drop-off in power is so marked at the fastest shutter speeds, HSS is most useful often when shutter speeds are only minimally faster than the usual X-sync setting. The table below gives a guide to the power made available from a typical flash unit using HSS:

NORMAL AND HIGH-SPEED SYNC. GUIDE NUMBERS			
	SHUTTER SPEED	GUIDE NUMBER (feet at ISO 100)	GUIDE NUMBER (meters at ISO 100)
Normal X-sync. Flash	1/60 sec.	120	36
	1/125 sec.	120	36
	1/200 sec.	120	36
HSS Flash	1/250 sec.	30	18
	1/500 sec.	42	13
	1/1000 sec.	30	9
	1/2000 sec.	21	6.4
	1/4000 sec.	15	4.5
	1/8000 sec.	10.5	3.2

HOW HSS WORKS

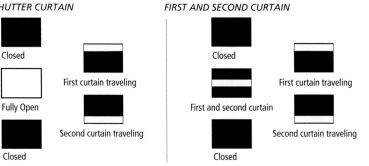

NORMAL X-SYNC. FLASH
Flash Waveform

Preflash Normal Flash Off

HIGH-SPEED FLASH
Flash Waveform

Preflash High Speed Sync. Off

SHUTTER CURTAIN

Closed

First curtain traveling

Fully Open

Second curtain traveling

Closed

FIRST AND SECOND CURTAIN

Closed

First curtain traveling

First and second curtain

Second curtain traveling

Closed

Shoot to crop

There is a trick to using HSS if you don't have the proper radio triggers: shoot to crop. Simply set your shutter speed to a speed above your camera's maximum synchronization speed, say 1/500 sec., and shoot the image. Once you see the black line and how it is oriented in the photo on your LCD screen, simply recompose to crop that section off. This way you can get an image without the expense of a triggering system.

Gels

Gels are made for color correction or color enhancements. When shooting under mixed or different lighting with color temperatures different than the average 5500K your flash is set for, you

Nikon D3, 35–70mm lens,
ISO 200,
1/250 sec. at f/4.5

Nikon D3, 35–70mm lens,
ISO 200,
1/400 sec. at f/4.5

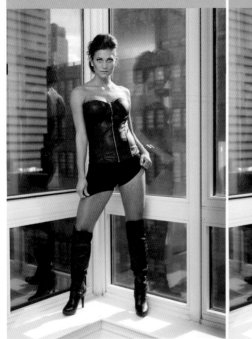

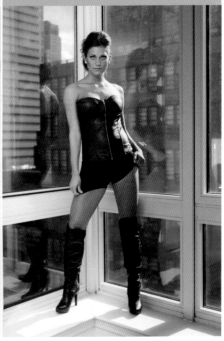

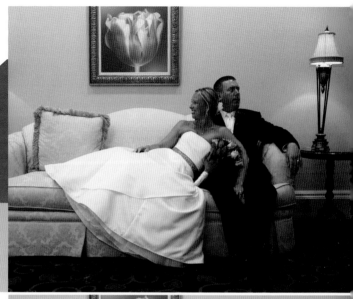

CTS GEL

The interior of this room was yellow, as was the tungsten or incandescent lighting. By gelling my on-camera bounce flash with a ½ Color Temperature Straw (CTS) gel, I was able to make the foreground lighting match the background light.

Nikon D3, 35–70mm lens, 1/60 sec. at f/4, ISO 1000, Nikon SB910, white foam paper bounce card, ½ CTS gel

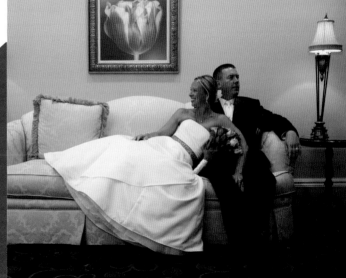

CORRECTED

With initial white balance correction done in software, you can see how even though the color was off in the first image, it is perfect here as foreground and background light now match and everything looks as the human eye saw it on the wedding day. Gelling your flash allows you to balance foreground and background lighting in these situations. In software, simply grab the white balance dropper and click on the white dress for instant color correction.

need a gel to correct for foreground light to make it match the background. In this case, you can use a few different types of gels.

The Color Temperature Orange (CTO) is the most common gel used to correct for warm or tungsten light. You need to bring the color temperature of your flash down from 5500K to about 3500K or somewhere in this range. The most common CTO gels are designated ¼, ½, or "full," which relates to the amount of light they cut (in stops). For instance, a ½ CTO gel will reduce the light output by about ½ of a stop of light. To compensate for this you can either increase the output on your TTL based flash (simply push the power up by ½-stop to compensate for the loss of light), or by increasing the ISO setting. This, to me, is the best option, as you can preset an exposure manually, set an ISO to a working level (such as 800 or 1000 depending on the light in your space), and keep your flash in TTL so it adjusts accordingly. At this point the automation takes over and the TTL technology built into your flash will add or subtract light as the camera tells it to. You have more and faster creative control if you adjust shutter, aperture, and ISO, and don't have to fiddle with your flash at all.

Assessment

By using gels for correction you have the unique ability to correct for lighting that doesn't match your flashes. In these images of the bride and groom on the previous page, the room is painted yellow, the light is yellow, but my flash is not yellow. But placing a ½ CTO gel on the flash head, I was able to get closer match to the existing condition with my flash; however, bounce flash also picks up the color of the walls that the light is bounced from. Here, the yellow cast on the image is due to wall color and my guesstimate on setting my white balance to about 3570K. In postprocessing, all I did was grab the white balance dropper and click on the bride's dress to correct for the whites. Overall, the white balance was not far off on the original image, but the colored walls contributed to the yellow color-cast of the original image.

In the image of a model showcasing a designer dress *(right)*, the temperature of the light outside was dropping as it started to get dark, so it's not close to the approximate 3200K temperature of the artificial light in the event room. Nor is it a match to the 5500K of flash.

Rather than try and match everything, I gelled the on-camera flash with a ½ CTO gel so that it had a color temperature somewhere between the two ambient light sources. The result is that the flash mixes well with the interior lighting, while the background outside has been transformed into a deep blue. This contrasts with the interior colors and provides a beautiful backdrop for the model. This is a direct result of the difference between daylight and incandescent color temperatures.

SETTING THE MOOD *(Opposite)*
By gelling my flash and working near the window, I enhanced the color drama between the interior and exterior light sources. The warmth of the interior light is correct on the model, but the daylight outside light turns blue due to the temperature difference.

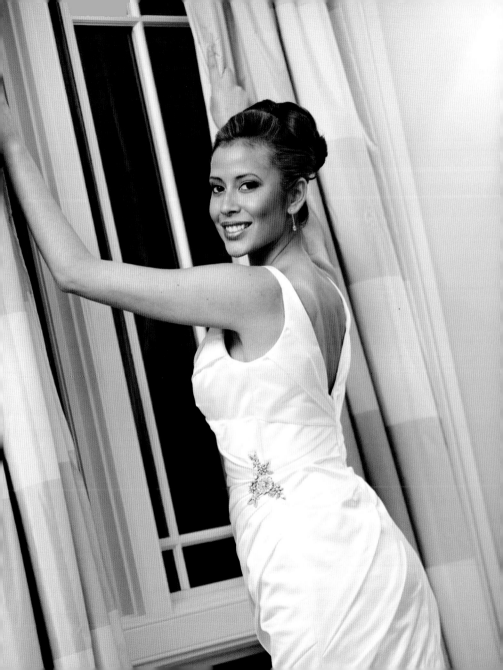

CHAPTER 3 OFF-CAMERA FLASH

Off-camera flash equipment

Getting the flash off your camera is one of the best things you can do to advance your photographic skills. The quality of light between on-camera and off-camera is incredible.

The difference stems from the fact that your flash is now off axis to your lens. That means that the flash is not directly on top of your lens, so even though you've learnt how to bounce the flash around the room and achieved great results, the next step is to get that flash off your camera and onto a lightstand.

The first question to answer is: which lightstand, which boom arm, which umbrella bracket? With a plethora of gear to choose from and the number of choices getting broader every day, let's try and simplify what you really need to enter the world of off-camera flash. Here's a list of what I keep in my daily professional kit—the kit that goes with me everywhere I go:

Nikon SB910 & SD9A Battery Pack

A professional flash unit for your camera system will give you ample power to illuminate your subject. Don't have or can't afford the high-end flashes? The third party entries in the market are good and cheaper than proprietary units. Manufacturers like Nissin, Yuongno, Vivitar, and Phottix all make powerful flashes that can be triggered either by a master flash on your camera, or by a triggering system like the Pocket Wizards. A Nission Di866, which has a higher guide number that a Nikon SB910, is also in my bag and I use it often as its power is outstanding.

BATTERY PACKS
The battery pack you choose will affect your flash output. The manufacturer's packs are best as they are designed for your flash unit; however, multiple options are available for aftermarket units.

Lightstand: Manfrotto 1052 BAC

The Manfrotto BAC or Quickstacker lightstands are lightweight, durable, air-cushioned, and reasonably priced. They fold flat and can be stored atop each other for ease of travel. Air-cushioning on the stand is another plus to look for when shopping for lightstands. After a shoot, when you're packing up and you loosen

the handles on the stand, the extension poles on the stand will slide into one another slowly and at a metered pace. This reduces the risk of damaging your equipment, whereas a non air-cushioned stand carries a risk of your gear crashing down. Not all stands are air-cushioned, but look for ones that are: they'll save your gear in the long run. I have six of theses stands in my larger bag and a full complement in my studio.

Boom arm: Matthews 40in. Hollywood Grip Arm

I chose and recommend the Matthews grip arm as a versatile and easily transportable boom arm because the arm is a stainless steel tube. Not only is the tube strong and can hold my larger studio strobes when needed, but also you can cut the stainless steel. Other brands are painted or chrome. Once you disturb the finish on

LIGHTSTANDS
Choose good, durable lightstands by a reputable company for quality, longevity, and serviceability. Stands by Manfrotto, Avenger, Matthews, and other top manufacturers will last you a lifetime; spend your money well up front and keep your stands forever.

BOOM ARMS
Boom arms come in all shapes and sizes. Your specific needs will determine your final choice on a boom arm, but the 40in. Hollywood arms are a great place to start: they work well and won't break the budget.

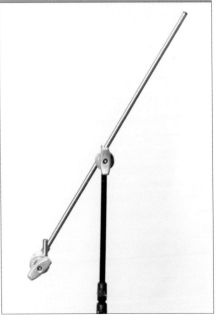

those units, you ruin them: the paint peels, the chrome, once you've cut through it, discolors and peels, and then your equipment looks shabby and worn. In the case of chrome, once the finish peels it may damage other pieces of gear or cut into or through your equipment bags.

Tip

I routinely cut my Matthews grip arms. I remove 4in. (50mm) from the bar with a hacksaw to fit the bar into a 36in. (1m) equipment bag and then file the end smooth. I take the remaining piece and stick it in my bag to use on the opposite end of my arm to put another flash on or hang a sandbag counterweight from.

Umbrella Bracket: Lumopro LP633

Choose an umbrella bracket that is durable. Many of the units on the market can be so cheaply designed that they can come apart. Remember, you're supporting an expensive flash unit, so it makes sense to get a good bracket. The Lumopros are made entirely of metal and can take a professional beating. While there are other solutions on the market, I've found these brackets to be sturdy and reliable. If you can, avoid any of the lower-end units on the market since you'll wind up purchasing them twice: once to save money, the second time to get the better unit. Why not just get the good unit to begin with?

UMBRELLAS
The umbrella you choose will affect your overall light output and quality of light emitted. Choose one that is convertible, which means that you can remove the black backing to use it either reflective style or shoot-through style (see page 56). Also be wary of the umbrella spines. The brand shown here, a Photoflex 43in. Convertible, has fiber composite spines, so if it falls over they won't break.

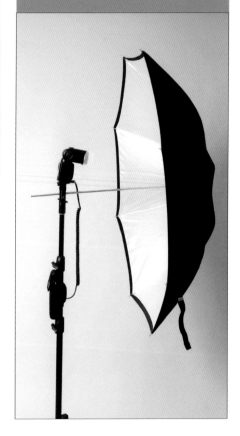

Radio triggers: Pocket Wizard Plus IIs & IIIs, Pocket Wizard Flex, Radio Popper PX System, various adapters

Choosing a radio triggering system can be tough based on budget and need. The two industry leaders are Pocket Wizard and Radio Popper. Radio triggers work like walkie-talkies. The camera recognizes the one on the hotshoe as the master and the slave is the one attached to the flash. Yes, you'll need two! But investing in a good and reliable system is paramount to your success. You want your flash to fire every time all the time, so getting into a system is important. Both the Pocket Wizards and Radio Poppers live in my bag. Each one has its own use and each one gets used frequently.

Batteries: rechargeable Ansmann 2850 Mah & Powerex MaHa 801D charger

Rechargeable batteries are another important component in the entire system. An external battery pack allows more flashes from your unit, but without good batteries the advantage of an external battery pack is lost, so choose good batteries and chargers.

Ansmann batteries live in all my flashes. I can get up to 1000 flashes with a Nikon SB910 set to manual mode at ½ power or in TTL and the SD9A external battery pack. This means I can shoot an event for a long time, and I can run a presentation or workshop without battery replacement every few hundred flashes.

RADIO TRIGGERS
The radio trigger market is flooded with options. Choose a well-known brand for service and reliability. Some of the cheaper brands may look attractive financially, but as always you get what you pay for.

Tip

When charging batteries, especially with a MaHa charger, choose the "soft charge" option. The best way to kill a battery cell in a short time is to "quick charge" it. Quick charging destroys the cell faster over time. Even though the soft charge method can take up to two hours if the battery is depleted, it will make the cell last longer.

Umbrella: Photoflex 43in. convertible umbrella

Convertible umbrellas should be a part of everybody's basic kit, whether using a speedlight or studio lighting. The convertible umbrella is such a versatile piece of gear that it is a key element to your kit. The other reason to own an umbrella is cost: a basic Photoflex, Westcott, Lastolite, or Creative Light convertible umbrella is reasonably priced. Owning a few of these is economical and a great way to achieve professional-looking images on a budget. Photoflex convertible umbrellas have been a key element in my kit since I started, and I use them often and very creatively.

Reflector: California Sunbounce Micro Mini with grip head

One of the best reflectors on the market is the California Sunbounce system. I use the word "system" often because you want to own

SHOOT-THROUGH UMBRELLA
Shooting through an umbrella allows you to aim, or feather, the light from one side to another, or off a subject's face and toward a reflector for softer, more even light.

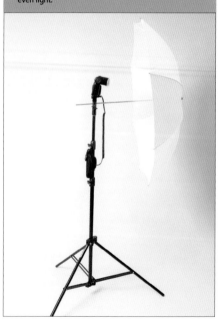

REFLECTIVE UMBRELLA
The reflective umbrella is the easiest to learn lighting with. Although it throws and scatters light, learning with this simple tool will advance your skills fast.

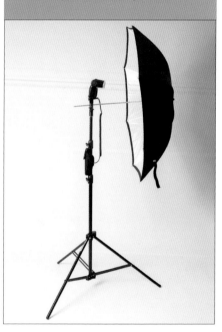

products that integrate easily and have simple compatibility. The California Sunbounce Micro Mini with grip head adapter, for example, is not only versatile, but also it allows me to work alone. I can set up my reflector, attach the grip head to the reflector and lightstand and just go to work. With the grip head, I have ultimate adjustability to go from one side to the other or under or even over my subject and not have to worry about having, or paying, an assistant to do that for me.

Basic setups

Let's take a look at a basic setup: one lightstand assembled with a reflective or shoot-through umbrella attached. The most important point to remember is to insert the umbrella shaft so the flash points as close to the center of the umbrella as possible. The flash head and central part of the umbrella will never meet exactly, but getting it close will give the best result. Take a look at the umbrella bracket below. I've attached a small "F" on the unit to mark the

REFLECTOR
The reflector is one of the most basic tools in the photographer's kit. From the small piece of foam board to the expensive versions, you should not be without one for efficient fill light.

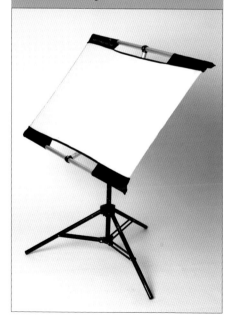

UMBRELLA BRACKET
Essential for mounting your umbrella on a lightstand is an efficient adjustable bracket. Note the "F" added to indicate the front.

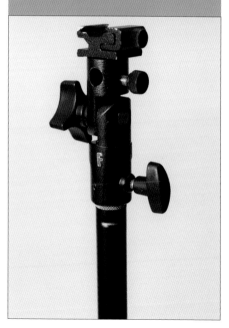

front. This way I know which side is the front, so when in a hurry I can assemble the unit quickly and not have to pay attention to flash direction on the bracket: it's already predetermined. All I need to do is go to work. When setting up your unit at home, try it both ways, see the difference, then go ahead and mark the front so you'll be ready to work at a moment's notice.

Buy a basic equipment case such as the one shown below, which you can throw over your shoulder. There are a many variations of this type of case, so shop and choose wisely.

Now let's look at your basic camera settings and equipment setup. Once you've taken the leap into off-camera flash, you'll be scratching your head as to where to start. What do I set my exposure to? Do I need a light meter? White balance? ISO? The questions will be spinning around in your head, making you dizzy, making you want to stop the madness and set it all aside and stop shooting off-camera flash. This book is designed to help you with all of that. We've taken the mystery out of getting started and help you to understand how the system works.

BASIC KIT
The basic kit will look something like this for the average off-camera flash shooter. Build a kit that allows you to move and work quickly and efficiently.

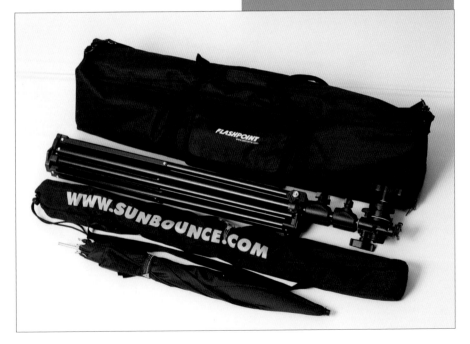

Camera settings

Let's begin with basic camera settings:

Shutter 1/125 sec.
Aperture f/5.6
ISO 200
White Balance Daylight or Direct Sun

Now that you have the camera set up, what about the flash? Take your flash unit and to start, go into the menus and switch from TTL to Manual Mode. In Manual Mode you've effectively turned your hotshoe flash into a strobe light with all of its attendant adjustments. You have the ability to go from 1/1 or full power to, in some cases, 1/128 power, which is just a smidgen of light. Once you set your flash this way, it becomes easier to understand how flash output to camera exposure selection works. If you set your camera to the base settings given, then all you have to do is test shoot and adjust from there. Not to complicate things, but *adjust*

WHITE BALANCE AND EXPOSURE
When your are starting out with off-camera flash, it's a good idea to jump-off from a consistent group of settings. I always suggest starting with the settings shown below.

TTL VERSUS MANUAL
Choose Manual Mode over TTL as Manual allows you consistent control over flash output while TTL will change as the surrounding lighting conditions change.

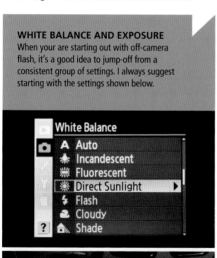

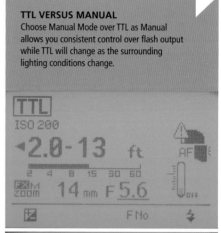

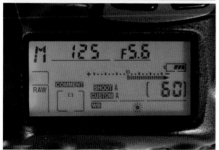

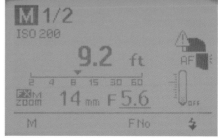

what? is probably the thought going through your mind at the moment, right? Once the camera is set up, what is the first adjustment you should make?

The exposure square

Remember that the exposure triangle basically consists of shutter, aperture, and ISO. Once you add the extra element—flash—the exposure triangle changes to the "exposure square." The exposure square now consists of shutter, aperture, ISO, and flash output. You now have the ability to adjust one more item on that list. Confused where to start?

Start with ISO so you can maintain a good shutter speed for handholding your camera/lens combination and a good working aperture for depth of field. If you go too slow on shutter speed, you may get a blurry image; keeping your shutter at 1/125 sec. will give you a good shutter speed for sharp images. Don't forget that everything is moving: you move, the subject moves (if it's a person), and even the

Tip

Focus on the eyes. The human eye is drawn to two places in a photograph: the sharpest part of the image, so you want your audience drawn to faces, and the brightest part of the image. Unless you are highlighting a specific product in the image, keep faces bright and well-exposed.

earth moves! Unless you are using a tripod, stick around the 1/125 sec. mark for shutter speed. If you adjust your aperture to f/4 or lower, you run the risk of softer images. While this may be a desired result for your final image, you need to pay strict attention to where you focus. This is especially true in portraiture, where you will need to focus on the eye closest to you to ensure you will keep important details in the face sharp.

That is the reason to start with ISO. If you find your images to be fractionally dark, boost ISO from 100 to 200 or 400, or somewhere in between full stops. Modern cameras are great at high ISOs—take advantage of that! But, as in all things in photography, if you are getting bright images at ISO 100, then adjust your aperture from f/5.6 to, for example, f/8, check the LCD, histogram, and blinking highlights. If all is good, start shooting.

That's it; that's your jump off point to begin your journey into off-camera flash. With these settings the mystery of the eternal question: "What are my camera settings for this shot?" is answered. While not every photograph you take will be this easy to figure out, once you have the basis of exposure, you have the foundation to begin.

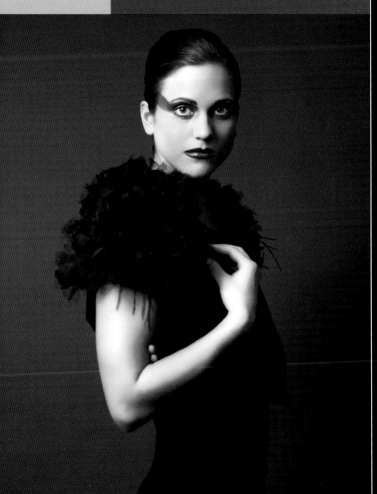

SIMPLE DRAMA
In this shot, a single speedlight and reflective umbrella has been used. It doesn't get easier or simpler than this setup. The main light is set at the traditional 45° x 45° portrait light location discussed on the following page, the exposure as shown left.

Nikon D3, 70–200mm
f/2.8 VR lens,
ISO 200,
1/100 sec. at f/5.6

Traditional portrait setup

The next burning question that is on your mind will probably be, "What exactly is the traditional 45° x 45° portrait light location?" When you're just beginning your journey into any kind of photography work, it is important to know and understand how to set the main light effectively.

You don't always need to work in this format since one of the basic rules of photography is: "Learn the rules, then break them!" The fact that you've chosen to go this far proves that you are willing to go the extra step to really figure all of this out.

To determine the traditional 45° x 45°

RULE OF THIRDS
For truly creative headshots crop off the head and put the eyes in the upper third of the frame.

Nikon D3, 70–200mm f/2.8 VR lens,
ISO 200,
1/125 sec. at f/5.6

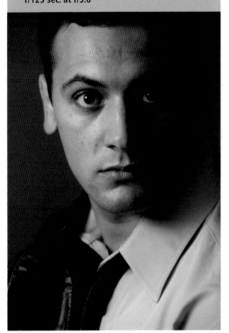

DEPTH OF FIELD
Longer lenses, like the 70–200mm lengths, offer great control of depth of field and creative tight cropping in your images.

Nikon D3, 70–200mm f/2.8 VR lens,
ISO 200,
1/125 sec. at f/7.1

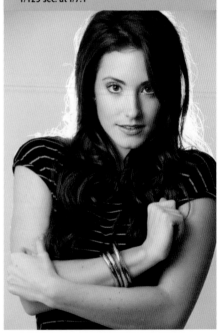

main light setup, all you need to do is stand in the middle of a fairly square room; kitchen, bedroom, living room, etc. Once in the center of the room, simply raise your hand until you can point to the intersection of the walls and

Nikon D3, 70–200mm f/2.8 VR lens, ISO 200, 1/125 sec. at f/4

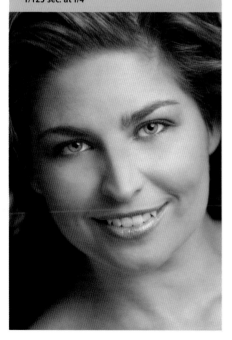

ceiling in one corner. In a square room, that should be about 45° x 45° off the subject. Remember, this is the subject's view. Then simply go to the side of the camera—your side as the photographer—and see the setup. Once you understand how the main light is set, you have the ability to work in the classic portrait style, but also understand that you don't need to work in this style all the time: this is just the starting point.

Now that I've probably got you confused at the beginning of your journey—I call it a journey because it's just that—the more you learn and shoot and try new things over time, the more you'll become comfortable with the process and begin to experiment with light in all its shape and form and controllability and uncontrollability.

Tip

Constant aperture lenses offer the most creative control for depth of field in your images. When shooting headshots or portraits, pay attention do your working aperture. For a corporate headshot you want enough sharp in the image from front to back so stick to working apertures of f/5.6–f/8. For creative portraits experiment with shallow DOF and open your aperture to f/2.8–f/4. This allows you to keep eyes sharp while shallow DOF helps to smooth your subject's skin as the falloff is so fast.

Get a head

One of the best ways to learn about light and exposure and the 45° x 45° traditional portrait light setup is to meet and use Sally. I call her Sally because I purchased her at Sally's beauty supply store. She's just an inexpensive styrofoam (expanded polystyrene) head that you would find in any beauty or wig supply store. With your own Sally, you don't need to ask, cajole, pay, or even bribe a family member to sit for you while you learn all of these initial lighting concepts.

Place the head on a table in your living room, kitchen, garage, or any spot in your residence and set up your off-camera flash gear. Now you can shoot at any time and at your convenience and you get the added benefit of having your model stay silent the entire time: again, there will be no complaining or poor posture or general bad attitudes: Sally is always ready to work.

You should pay attention to important exposure latitudes here, since this is the perfect time to learn how exposure works. Look for blinking highlights: if they happen,

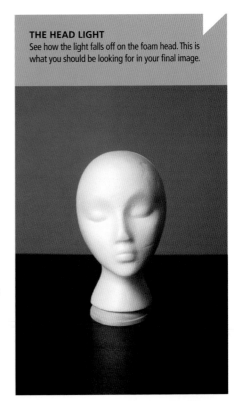

THE HEAD LIGHT
See how the light falls off on the foam head. This is what you should be looking for in your final image.

Tip

Turn your highlight clipping on in your camera. This technique is a great way to learn exposure and how to read your clipping in the camera. The white foam is so reflective that you can see immediately where the detail is missing and adjust exposure accordingly.

adjust exposure so you don't see them. Consult the histogram: it may be skewed to the left or to the right depending on your backdrop. As long as exposure is good on Sally, however, don't pay too much attention to the backdrop as your model is the most important part of the exercise.

The first image, shown on the facing page, illustrates the traditional 45° x 45° portrait light setup.

45° X 45° TRADITIONAL PORTRAIT LIGHT SETUP
The home studio can be set up and broken down in a matter of minutes. Utilize the space when no one else is at home and you'll learn quickly how to set and expose for your light.

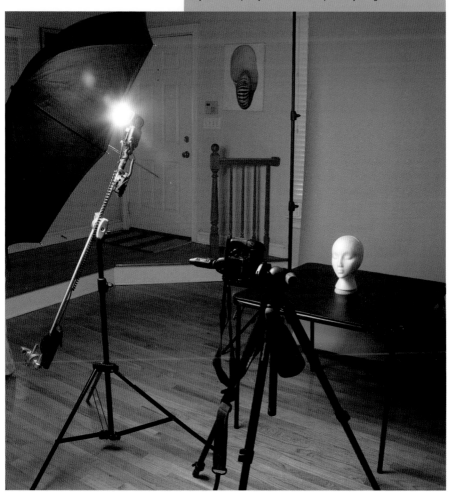

Once you've understood how and where to place your main light, start to move it around Sally and study how the shadows fall:

SIDELIGHT
With this type of light, one side is lit perfectly while the other side falls into shadow. The dramatic nature of this light allows you to draw attention to the edges of your subject, like the muscles of a bodybuilder or in food photography, where you want edge detail and not broad soft light all around.

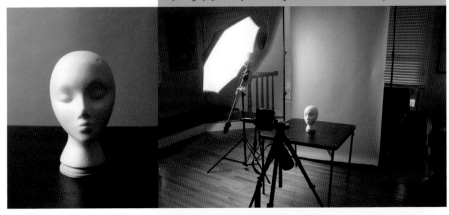

TOPLIGHT
This light creates dramatic shadows below the features of the head. Place a reflector on the table to remove the shadows: this "beauty" or "over and under" light, used in fashion and beauty photography, is soft and pleasing.

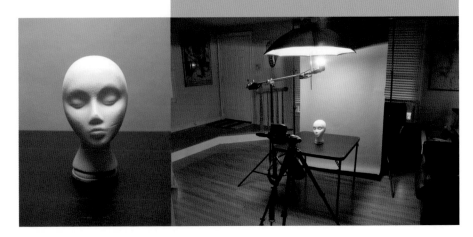

Now with the help of Sally, you have the ability to understand the concepts of lighting a subject sensitively. It doesn't matter if the subject is a person, a vase of flowers, or a product pack shot. The idea of this chapter has been to get you to understand light in all its forms and how to use it effectively and creatively. Once you can do that, there is nothing that will inhibit your creativity or how you use your flash equipment.

DIRECT FRONT LIGHT
This typed of light fills pores and details in the skin so that the skin looks better or smoother than it really is. The light actually fills the pores and smooths the skin without being too flat with contrast.

Depth of field

When out shooting it is important to pay attention to where you focus your camera lens. For portraits, you always want to try and focus on the eye closest to you as you are usually using wider apertures like f/4, f/5.6, or f/8; for landscapes, focusing into your scene by about $1/3$ will allow DOF to work for you and get more sharp in the image from front to back as you are usually working at apertures of f/8 to f/22. In this three speedlight, high-key image, I focused on the model's eye closest to me. You can see that while shooting with a long lens at an aperture of f/5.6, her left eye is razor sharp but her right eye immediately falls out of focus. It is important to pay attention to where you focus on any subject so depth of field works to your advantage, especially in portraiture where your viewer is drawn to the sharpest and brightest point in the image.

Nikon SB910 at ½ power, large Rogue Flashbender with diffusion panels as flags to light background separately.

Metering

Using the in-camera meter to set the exposure is the best way to work creatively. Here, I set the model so the sun coming from the left gave a broad hair light. To compensate, I set my camera to spot meter and took a reading from her face. This type of metering only looks at a spot in the viewfinder, usually the focal point. I focused on her right eye, got a good reading for her face and let the sun highlight her hair. Do this by keeping your meter in 3D Matrix, evaluative, or whatever the camera's default mode is and then zoom in and set the exposure, ignoring the over or under reading in the viewfinder. To add light on the left, I set a Nikon SB800 with a warming gel directly behind her head. By adding the small, warm flash, I opened up the right side of the image so the hair would not fall into shadow. You can see the warm tone through her hair on the lower right side.

Nikon SB800 at ½ power, ½ CTO warming gel.

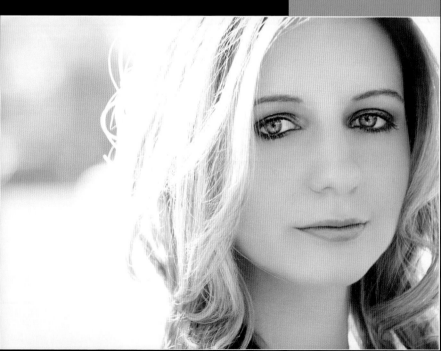

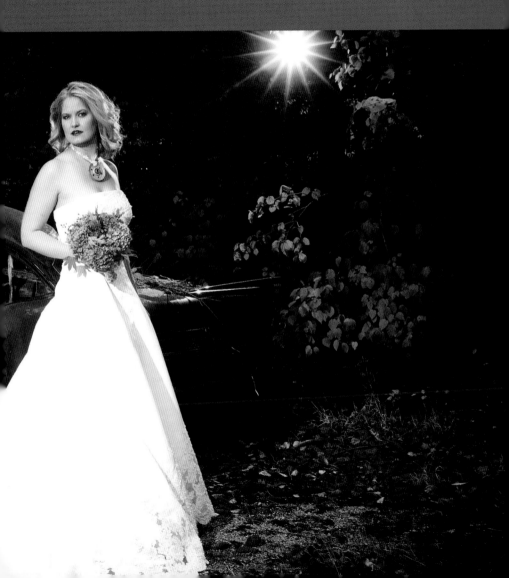

Shooting situations

Now that we've covered the basic equipment needed to get the flash off your camera and onto a lightstand so you can take your work to another level, we're going to look at actual shooting situations, dissect them, and really get you involved in small flash photography.

With the amount of information available to you on the Internet, it becomes important to really pull apart what is being said and what is practical for you to use in your own photographic work. My goal has always been (and always will be) not only to get as many people involved in off-camera flash (OCF) as possible, but also to show you efficient ways to spend your money. Don't become the photographer who suffers from what Nikonians call NAS, or Nikon Acquisition Syndrome. As soon as a new piece of gear is released by Nikon, this select group of shooters salivates over the new product until it's in their bag, whether they need it or not!

We are into OCF for the fun, the creativity, the portability, the accessibility to great equipment and techniques that once only belonged within the realm of working professionals, and the money; yes, the money—it's a business after all. But what suits one photographer the best may not suit you and you may wind up like many of us with shelves of gear you don't want, need, or use. You end up with credit card bills, in spats with significant others over costs you may never regain, and with a touch of heartache over your enthusiasm to succeed that may not pan out. I

know, as a professional freelance photographer, all too well the pitfalls of the industry. I once had a student ask me, "How do you make money in photography?" I replied, "Stop buying gear."

But now you are at the point where you may need to get some gear to either get started or replace old stuff, or just expand your lighting repertoire. This chapter deals with OCF equipment. We'll look at images taken with certain gear, at the gear itself, and then you can decide what is right for you. Each piece of gear has its own pros and cons, and we'll look at a bunch of shooting situations and review the gear and how the shot was taken. This chapter should help you make the right choices for equipment selection. All of the gear showcased here I own and use or have used professionally and will be reviewed with an unbiased opinion so you can choose what will work for you.

Radio triggers

The two major forces in the radio trigger market are Radio Poppers and Pocket Wizards. The idea is to fire your flash from a distance without having to use a PC cord. The PC cord is just that: a cord that connects your camera to the flash. Usually they are about 10ft (3.48m) long

and plug into the PC sockets located on the camera and the flash. The problem is that on lower end cameras there is no PC socket. Now what does one do to fire the flash once you've taken the leap to get it off the camera? The radio trigger solves that problem.

Radio Poppers is one brand of radio triggers at the forefront of OCF technology. There are two types of triggers in the system: the JrX, which is the basic radio frequency

PX RECEIVER 1
The Radio Popper PX is one of many radio triggering systems on the market that allow you to use existing in-camera TTL metering for your off-camera flash.

RADIO POPPER PX
When using high speed synchronization, it's important to keep your flash head bare and close to your subject. If you place a flash into a softbox or umbrella, you'll lose too much light in between flash and subject.

Nikon D3, 70–200mm VR lens, ISO 200, 1/8000 sec. at f/2.8, ISO 200, direct flash

RADIO POPPER PX
Radio Poppers allowed me to use in-camera TTL technology. I adjusted shutter speed from 1/8000 sec. to 1/640 sec. and shut down the bright ambient light to get a great exposure on a sunny day.

Nikon D3, 70–200mm VR lens, ISO 200, 1/640 sec. at f/4.4, ISO 200, direct flash

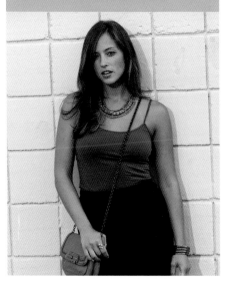

Nikon D3,
70–200mm VR Lens,
ISO 200,
1/3200 sec. at f/3.5,
direct flash

AMBIENT EXPOSURE

Effective use of high speed synchronization allows you to darken the background in bright ambient, or available, light. Simply place your bare-head flash close to the subject, set a shutter speed to underexpose for the prevailing conditions, and fire away, reviewing on your LCD screen as you go.

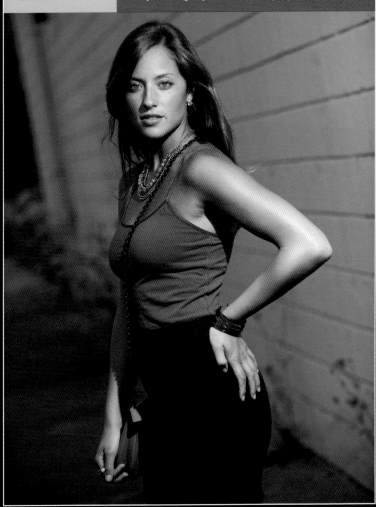

transmitter, and the Radio Popper PX system, which takes the proprietary infrared signal from an on-camera flash or on-camera transmitter such as an Nikon SU 800 or Canon STE2, converts that infrared signal to radio frequency, then converts it back to infrared on the attendant flash off the camera. This all happens within a split second and there is no time lag on any of the transmission.

The great thing about the Radio Poppers PX is the ability to use the proprietary master and slave features found on Nikon and Canon flashes, or the Nikon Creative Lighting System. With the PX system, TTL and Manual modes can be used to shoot great images and have all the controls at your fingertips.

At the camera, you can switch from TTL to Manual, you can add or subtract flash power, and you can control multiple flashes in three groups. The most innovative part of the PX system is the ability to use High Speed Synchronization. Now you can use higher than normal flash synchronization speeds to get great results in bright outdoor light.

Note

The Radio Popper flash adapter bracket—the bracket that lines the infrared sensors on the trigger and flash so the system works—is a bit clunky in size and shape. The bottom is flat and has the usual ¼ x 20 thread to accept light shaping attachments, but the unit won't attach to any umbrella bracket. Therefore you also need to purchase the Manfrotto #3298 adapter and screw it on to the bottom of the Radio Popper bracket.

ADAPTER ONLINE
Using the Manfrotto or similar adapter allows you to use existing lighting gear without the added expense of replacing equipment you already have.

Pocket Wizards There are two types of Pocket Wizards: the Plus III, which is a radio transmitter only, and the Flex system, which allows for full TTL control of your flashes with a small gadget called the AC3 Zone Controller. The Pocket Wizard system is a proven system that allows you the flexibility of firing your flashes off the camera with a stable radio frequency signal. The Flex System also allows you full TTL control with high speed synchronization to shoot with very high shutter speeds and really control the light for whatever lighting situation you find yourself in.

One of the advantages of using a dedicated flash triggering system is not only the ability to add depth and drama to your photos but also to get your flashes into locations or even outside windows to create the kind of light you want, but that may not exist on that particular day. By being able to locate your flashes outside a window or around a corner, or in a different room altogether, your work will take on a new look and you'll be energized and ready to shoot from outside to in or from inside out. In this series of simple practice images, I used the Radio Popper PX system and set my flash outside the window to get some simple yet dramatic lighting on the floral still life.

Nikon D3, 35–70mm lens,
ISO 200,
1/400 sec. at f/4
Nikon SB800 direct flash

REAL WORLD SHOOTING
In this simple wedding shot a single SB800 was fired off-camera by the Pocket Wizard Flex. My assistant held the speedlight off-camera and to the right to illuminate the entire group and use some of the bright sun in the background as hair, edge, and separation light.

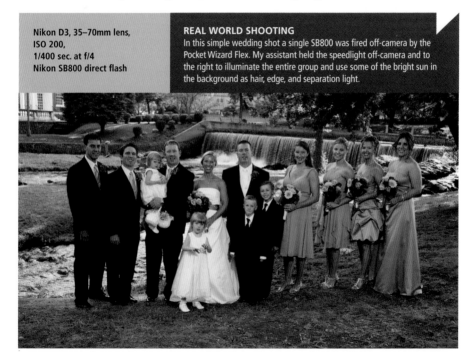

RADIO TRIGGER CHOICES

There are many radio triggers on the market. Before purchasing, do your research and choose a system that suits your needs and budget. Pocket Wizards are the industry default standard for a reason.

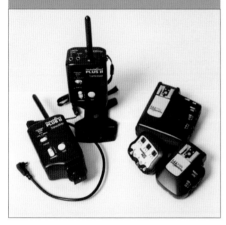

FLORAL STILL LIFE

Here's the setup. Notice the SB910 outside the window being controlled from inside the room. This is the beauty of a good radio trigger: wireless flash freedom!

RADIO POPPER PX

This natural light shot is not bad, but it could use some shadowing to give it more drama. See overleaf for the solution.

**Nikon D3, 70–200mm f/2.8 VR lens,
ISO 400,
1/30 sec. at f/2.8.**

SMOOTH SIDELIGHT

Radio Popper PX in Full Automatic TTL Mode, Nikon D3 with an SB800 master flash controlling an SB910 outside the window in Program Automatic, 1/60 sec. at f/5.6, ISO 200. Look at dramatic lighting and the lines on the table giving the effect of a smooth sidelight.

BACK AND FOREGROUND LIGHT

Radio Popper PX in Full Automatic TTL Mode, Nikon D3 with an SB800 master flash controlling an SB910 outside the window in Manual Mode, 1/60 sec. at f/4, ISO 200. Here I opened up my aperture by 1 full stop to add some back and foreground light on the shadow side.

Manual flash

When first starting in OCF, begin by setting your flash to manual mode and stay away from TTL or any of the in-camera Commander modes of Nikon or any other flash system. TTL can be problematic, since it wants to adjust for the ambient or available light all the time. The problem with this system is not only the learning curve, but also the inconsistency of the flash output. Once you get an idea of how manual flash works, then work backward and explore the TTL features of your flash system.

Manual flash is easy to set and to expose for, so until you've gained the confidence to attempt TTL, although it is highly recommended, stick with manual. Once in Manual Mode, simply scroll down until you get to ½ power. Once at this setting, your exposures will be in the range of 1/125 sec. at f/5.6, ISO 200. These settings are only for your starting point in OCF, but try them and see how well you do right away. Most students, even though their images may be under- or overexposed, realize how easy this can be once the mystery of TTL is removed and flash output is standardized at one power setting: ½. After that, adjust away!

TTL
When using on-camera flash, use the through-the-lens mode on your flash. Camera and flash combinations have become adept at understanding and figuring out exposure for you—why not take advantage of them?

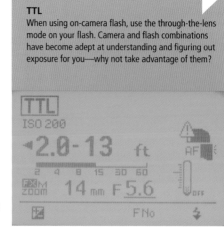

MANUAL
Using your flash in Manual Mode for off-camera flash effectively turns your flash into a strobe light. Your flash output will remain constant at every setting until you run out of battery power.

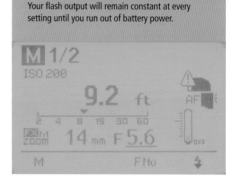

Basic OCF setups

While intimidating at first, OCF is fairly simple to execute. One of the first things you need to learn is main light placement. Begin by placing your main light in the traditional 45° x 45° portrait position. Once you have the hang of setting things up in the way portrait photographers have been doing for years, then change it up. There are no set rules to light placement. The greatest photographers are masters of light and they continually study it and look for ways to shape it to their needs. You are no different to them. Much of this is trial and error experimentation: learn and master the basic main light setup, then get creative and make art with your light.

Bounce light

Just like bouncing your light around the room with on-camera flash, one of the simplest ways to use your off-camera flash is to simply bounce it around where you are shooting. It doesn't matter if you are inside or outside, simply place your flash near a wall and bounce it off that wall or where the walls and ceiling meet. This method is simple and effective for getting great and soft results on your subject and in the final image. But beware, bouncing light—especially off a dark and porous surface, like the stone wall in the setup image below— loses a great deal of light output. You'll find yourself changing your settings and having to experiment to get the shot you want.

Nikon D3, 50mm 1.8 lens, ISO 400, WB Daylight, 1/30 sec. at f/4, Nikon SB910, Manual Mode, ½ power

BOUNCE LIGHT
The photograph, below left, was achieved by bouncing the flash light from the wall, as shown below right.

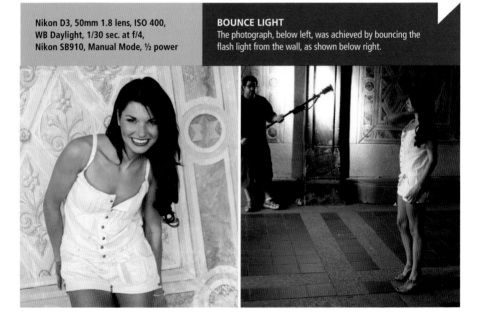

The convertible umbrella

The versatility of the convertible umbrella is amazing. You can do so much with just one inexpensive piece of gear. The convertible umbrella should be in every photographer's basic kit. It is highly versatile and can be used in a variety of situations. It is lightweight, folds just like its name implies, and can produce some incredible work. The convertible umbrella can be used in the reflective style or the shoot-through style. When used as originally intended, the reflective umbrella gives beautiful contrasty light that has a cool tone and can be used to illuminate a broad area to give a simple wrapping light to your subjects and make them "pop" from almost any background.

**Nikon D3, 70–200mm VR lens,
ISO 200, WB Daylight,
1/125 sec. at f/5.6
Nikon SB910, Manual Mode, ½ power**

REFLECTIVE LIGHT
The photograph, below left, was captured by reflecting the flash light with a convertible umbrella, as shown below right.

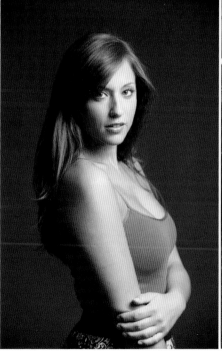

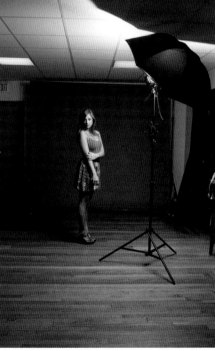

Shoot-through umbrella

The shoot-through umbrella is even more versatile. Set up in this configuration, with the black backing removed and the hotshoe flash aimed through the diffusion layer of the umbrella, the light can now be aimed either toward or away from the subject to determine how the light will illuminate it. Being able to aim the light to one side or another allows you to shape it, and add or subtract softness. By allowing the light to spill onto the subject and not light it directly, the shoot-through umbrella turns into a large, soft, broad light source.

If you take a close look at the setup shot below, you'll see that the flash is not pointed directly at the subject. In this case, the flash is

Nikon D3, 70–200mm VR lens,
ISO 200, WB Daylight,
1/125 sec. at f/5.6,
Nikon SB910, Manual Mode, ½ power

SHOOT THROUGH THE UMBRELLA
This photograph, below left, was captured by firing the off-camera flash through the umbrella, as shown below right.

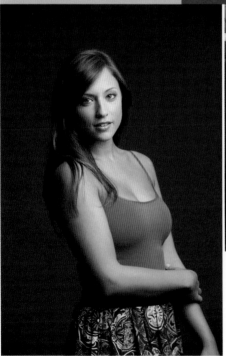

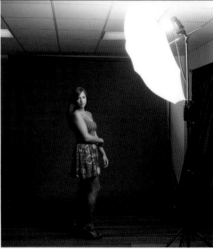

filling the area around the subject and soft spill light is falling on her and illuminating her. The flash and shoot-through umbrella combination is actually lighting around the model and lighting her indirectly.

In the next image below, taken immediately after the previous image, a reflector was added to the setup. If you look closely again, you'll not only see that the flash and umbrella are not pointed directly at the subject but are in effect pointed at the silver side of the reflector, effectively sandwiching the model with indirect lighting. We are then exposing for indirect and soft fill lighting as our total main light, which gives us this fabulous soft portrait light.

Nikon D3, 70–200mm VR lens,
ISO 200, WB Daylight,
1/125 sec. at f/5.6,
Nikon SB910, Manual Mode, ½ power

SHOOT THROUGH UMBRELLA WITH REFLECTOR
This photograph, below left, was captured by firing the off-camera flash through the umbrella and reflecting light for fill on the model's face, as shown below right.

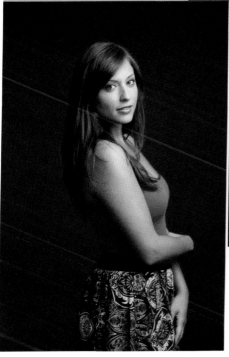
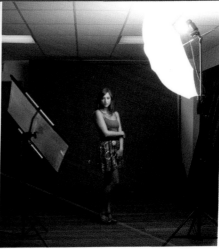

The softbox

Small softbox

The Rogue Flashbender system shown below is one of the most versatile and small light modification systems on the market. In this setup, the model is about 5ft (1.5m) from the main light source and framed by a doorway. Framing your subjects or getting them close to an edge of a wall or door is a great way to pose easily. The light is coming from overhead. giving a flat frontal light that helps to diminish skin imperfections, but still retains detail in the skin and clothing. The look is simple to achieve and you can see the Matthews grip arm at work. Getting your flash high, above, and out of the way gives you the flexibility to move around the shooting area and also get that direct flat light.

Nikon D3, 50mm 1.8 lens,
ISO 200, WB Daylight,
1/125 sec. at f/4,
Nikon SB910, Manual Mode, ½ power

FRAMED
With the model framed in a doorway and the softbox high above her head, the perfect direct flat illumination was achieved.

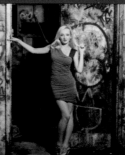

THE ROGUE FLASHBENDER
The Rogue Flashbender is designed to be bent into different configurations to place light where you want it and keep it from where you don't. A diffusion panel can also be added, turning the Flashbender into a small softbox.

Medium softbox

The setup image below right shows the location of the main image, and single Lastolite 24 x 24 Ezybox. It is approximately 45° x 45° from the subject, but you can see that it looks skewed from the photographer's perspective. When we view the scene from our side it looks more complicated than it is in reality, so it becomes important in the beginning to sit where the subject will be to fully understand how the light sits. You can adjust right to left, front to back, or higher or lower, but the initial placement of the main light will be easier to understand when viewed from the subject's perspective. The setup when executed well gives us the perfect one light headshot with detail and shadow.

Nikon D3, 70–200mm f/2.8 VR lens, ISO 200, WB Daylight, 1/125 sec. at f/5.6, Nikon SB910, Manual Mode, ½ power

SINGLE LIGHT HEADSHOT
The position of the single, angled softbox was crucial to light the model sympathetically in this outdoor daytime shot.

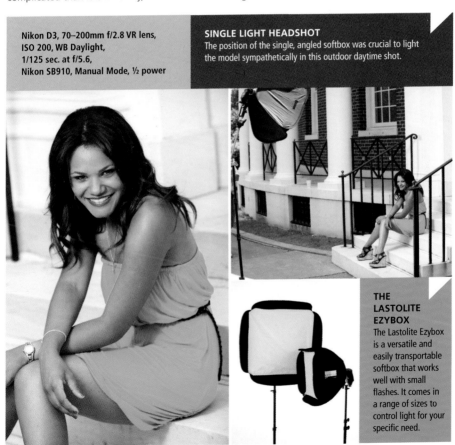

THE LASTOLITE EZYBOX
The Lastolite Ezybox is a versatile and easily transportable softbox that works well with small flashes. It comes in a range of sizes to control light for your specific need.

Body sculpting

Softboxes are often preferred over umbrellas for their control of light. The Westcott 28 Apollo, used here, allowed for ultimate light placement on the stomach of the model, which made skimming the light across his abdomen smoother and with more control than if an umbrella were used.

Nikon D3, 50mm 1.8 lens,
Westcott 28 Apollo,
ISO 200,
1/125 sec. at f/5.6

Feathering the light

The Westcott 28 Apollo gives a soft beauty light when used effectively. To get this result, simply feather the light. Feathering the light means you point the main source of light away from your subject. There is an old adage in photography: don't light your subject, light around it. In this case, simply turn your light source one way or the other to get soft directional light and those deep, soft shadows.

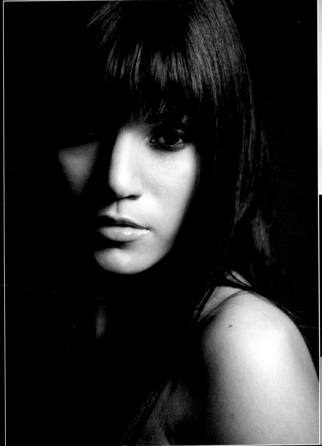

The Westcott 28 Apollo has a unique umbrella frame design that allows it to be collapsed for storage and transport. Once opened, it has the control of a much larger and more unwieldy softbox.

Nikon D3, 70–200mm f/2.8 VR lens, Westcott 28 Apollo, ISO 200, 1/125 sec. at f/5

The classical touch

The Creative Light Softbox used in this setup is based on a professional softbox frame and has a fitted grid that can be attached to the front for versatile light control. These softboxes don't break down easily and the steel rods that give the softbox it's shape have to be assembled a few times to remove some stiffness and be broken in, but the attachment ring (speedring) for the flash is sturdy and well built. Light quality from this size box, 24in. x 36in. (69cm x 914cm) is about the best for small flashes.

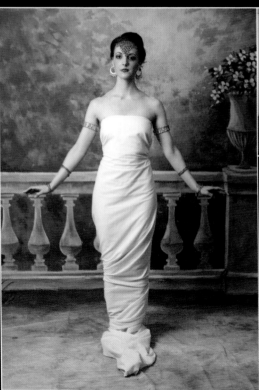

Nikon D3, 50mm
1.8 lens, Creative Light
24 x 36 Professional
Softbox, ISO 200,
1/160 sec. at f/5

Quality of light

As photographers, the choice is up to us to determine what kind of light to use. Light is the essence of photography; without it, we can't get an exposure to register on our film or digital sensor. Light is our muse, our friend and foe, for light, in all of its forms, must be handled with care so the end result reflects our vision.

Hard light

Hard light is just that: hard and unforgiving. We can use the harsh nature of light to get creative and turn it to our advantage. Why not go out and shoot at 2 o'clock in the afternoon? Why avoid the harsh shadows of broad daylight? Why wait till the golden hour for that perfect light? Does the sun wait for us? No. What we need to do as photographers is to learn how to use this light to our advantage and add supplementary

Main light: Nikon SB910 into a Large Rogue Flashbender, with diffusion panel
Backlight: Nikon SB800, Large Rogue Flashbender, CTO Gel, diffusion panel

SUN THROUGH THE TREES
In this three-light setup, the sun streaming through the trees is the hair and edge light on her right leg. A Large Rogue Flashbender with diffusion panel and a warming gel is used as the hair and edge light on the model's left. And finally, a Large Rogue Flashbender with diffusion panel is used as the main light.

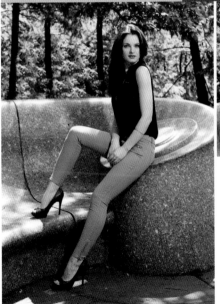

or fill light to get the shot. In the studio, consider using a grid or snoot as a main light. Create, experiment, look for light that you don't normally see, don't just go for the softbox option; go for a look you're not used to and try something new!

In the image above, the model is sitting on a granite couch near Belvedere Castle in Central Park, NYC. Shot at 2 p.m., the model was positioned so that the harsh overhead daylight

streamed through the trees and just hit the top of her right leg and head. I used the hard light coming through the trees to my advantage. Then, I used off-camera flash as back and separation light and then as a main light.

In the studio, while going for the classic 40's Hollywood Glamour look of George Hurrell, as shown in the setup below, the model was lit using a series of snoots and grids. This type of look is one that was perfected by the glamour portrait artists of the late 20s, 30s, and 40s. By choosing a specific theme I was able to light my subject with modern tools to get that hard lighting, common to hot-lighting of the era. This is a departure for a great many photographers who always seem to be looking for that perfect light. Well, forget about the perfect light and go for something

Main light: Nikon SB910, Small Rogue Flashbender rolled into a snoot
Hair light: Nikon SB800, Large Rogue Flashbender rolled into a snoot.
Gobo light: Nikon SB800, Rogue 45° Grid

HARD LIGHT
Look for examples of creative lighting in magazines or online to challenge yourself to try new lighting styles. The image on the left was influenced by a photograph found online of a famous 1940s actress.

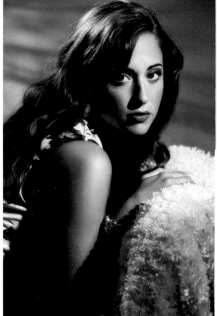

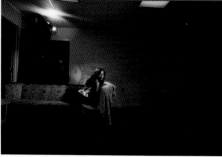

different. Try something new. Get out of that soft light rut and get into hard, contrasty, and unforgiving light.

Notice the hard loop light under the model's nose and chin, notice how the light is unforgiving and hard and just brutal on her skin. This is the creativity of light. Why not experiment with a style, with a look, or with a concept outside your comfort zone? You may be surprised at the results.

Medium light

Medium light is just what the term suggests: it falls somewhere in between hard and soft light. This type of light suits many photographic styles that want to capture that in-between look: not too hard, yet not too soft. The lighting in the setup below is very much like the light coming from a beauty dish. This is like a giant salad bowl attached to your flash and is a favorite of fashion photographers due to it's unique ability to shape light and shadow. You are able to capture great detail with light fall-off, but also capture the smoothness of skin and tone. The characteristics of this light fall in the realm of a one light portrait or editorial shot with a medium light modifier or even a scrim to diffuse the hard light of the sun, speedlight, or

Nikon D3, 70–200mm f/2.8 VR lens,
ISO 200,
Main light: Nikon SB910
Lastolite 24x24 Ezybox

MEDIUM LIGHT
This portrait, taken in the classic 45° x 45° main light setup, is dramatic and shows effective use of one light. The light is set to illuminate my subject and to put some light on the background, thereby using one light as two sources.

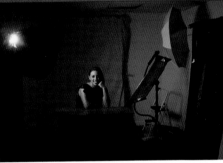

strobe. The light falloff is soft but hard at the same time, giving us that in between look of medium light, which is characterized by soft yet deep shadows.

The model was lit with just one light and a small softbox. You can see the soft, subtle changes of light on her face, which is characteristic of the lighting captured in the paintings of Rembrandt. Soft and full on detail on the highlight side, yet dark with smooth

shadow falloff on the shadow side.

Medium light, as illustrated in the simple studio setup below, can also be direct, forward light that gives us some soft shadow detail under the model's nose and chin and which is also exemplified by the short drop shadow on the wall.

Illuminated by one light source only, the model was placed as close to the wall as possible and posed simply as if sitting on a porch deck or chatting with friends. The lighting is frontal and flat, but it is not overdone. The approach here was to capture medium depth shadows with front light but not to overwhelm the skin or clothing of the subject. Medium light is a favorite of many photographers since it is easy to execute and the results can be truly fantastic.

Nikon D3, 70–200mm f/2.8 VR lens,
ISO 200, 1/125 sec. at f/5.6,
Nikon SB910,
Large Rogue Flashbender Diffusion panel

MEDIUM LIGHT
The Large Rogue Flashbender with diffusion panel attached is set high and above the model for bright clean light on her face with a very short drop shadow under her nose, chin, and on the wall behind.

Soft light

Now on to the lighting most of us strive to attain: that beautiful soft light that is just so flattering to all subjects young and old. This is the kind of light photographers chase during the "golden hour" of daylight when many portrait or high school senior or family sittings on the beach are booked. Photographers spend oodles of money buying softboxes, beauty dishes, umbrellas, and so on,

to emulate this light, because this beautiful, soft, pleasing look not only flatters our subjects, but also keeps us out of Photoshop.

In the setup shown below, the model was photographed much the same way as the model for medium light. She was lit with direct frontal flat light. This is a common soft lighting style that maintains skin texture and tone and illuminates the highlights and shadows in one

Nikon D3, 70–200mm f/2.8 VR lens,
ISO 320, 1/125 sec. at f/5,
Photoflex 45in. shoot-through umbrella

SOFT LIGHT
The lighting here is direct and soft. The shoot-through umbrella is one of the most versatile light modifiers a small flash user can own. It is lightweight and can be used in a multitude of ways. It is set high and above the subject and pointed at the model.

shot and with one light source. This is a personal favorite lighting style. I love the soft flat light that makes my subjects almost glow and look their best. With this style, any irregularity in the skin is washed out, but tone remains.

In the next image, shown below, the model is lit using the traditional 45° x 45° main portrait light setup. As before, this light is also soft and pleasing, but you it allows you to retain a bit more shadow detail on the skin.

Look at the placement of the main light in the setup shot. The main light is not pointing directly at the subject or aimed directly at the reflector: instead, it is pointed somewhere in between the two.

Under this lighting condition, the model is lit perfectly and the reflector adds just that touch of fill light for that perfect combination of main and fill light that gives off that radiant soft effect we all strive for.

Nikon SB910,
Creative Light 24x36 softbox,
California Sunbounce Micro Mini,
Two SB800s, grids, and blue and green gels

HARD AND SOFT LIGHT
The larger the light source, the softer the light. Remember this when lighting your subject. Here, the softbox offers a broad, soft, main or key light on the subject. Mix that with the hard light of the grids in the background and a multiple light setup mixing different qualities of light offers another dimension to the image.

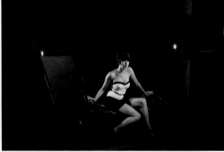

Tip

When using edge lighting set your lights behind your subject and off to the sides. This is the 45° x 45° portrait setting in reverse. You want light to skim across edges to give separation and detail, but don't want the light to enter the camera lens and create flare.

Ring light

The ring light look goes in and out of fashion over time. Popular one year and not the next, ring light has a unique and specific look, giving you a short drop shadow and flat front light without being flat light. The light from the ring envelope's your subject so it is distinct with a short drop shadow and wrapping light. The light fills the skin's pores so no shadow detail is seen and the skin appears to glow, which also helps during the finishing process as pimples and blemishes disappear.

It is also ideal for skimming light across subjects to gain detail and is often used in product photography. The light fills every gap and seam: highlights and shadows fall so that edges are brought out while shadows remain deep. The ring light is an essential tool as it gives different looks and can be positioned on or off camera and can enhance any subject.

Nikon SB910,
Creative Light 24x36 softbox,
California Sunbounce Micro Mini

RING LIGHT
Nikon SB900 above as main light at ½ power SB800 into an Orbis Ring Light on the right SB800 bare head flash as back light.

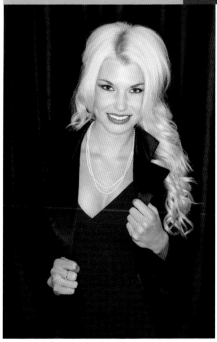

The best light

"The best light is soft light," someone said to me once. I fully disagree. The best light is the light that is available to you, the light you choose to use, and the light that best suits your purpose. I prefer this quote, which I read online. I don't know who said it, but it encompasses everything, every nuance, and every choice concerning light: "Is that the best you could do with the light that you had?" With that in mind, go out at two in the afternoon in the blazing sun, look for medium light, create soft light to flatter your subjects, and use light to your advantage.

Real world shooting: one light portrait

One of the great advantages to using off-camera flash is taking your gear on location. Portability makes OCF easy to use; coupled with your camera's LCD and histogram features, you can get nearly perfect and creative imagery within minutes of arriving on scene. Here, the model wanted portfolio shots different to those she had already. We met at an old abandoned antiques shop and in about five minutes I was creating the shots she wanted. It was a bright sunny day, so we moved into the shade of the building. Look at how she is lit and how simple a one light portrait can be. I bent my Extra Large Rogue Flashbender to keep light off of the background and only skimmed light on my subject. The final result is dramatic as the light falls across the edges of her body showing her toned physique. As you can see in the behind-the-scenes shot, she's happy with our results.

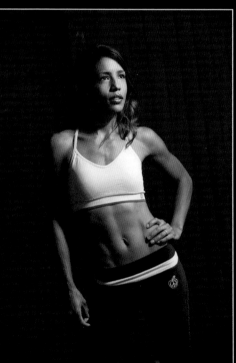

Nikon D3, 70–200mm f/2.8 VR lens, ISO 200, 1/400 sec. at f/5.6, Radio Poppers PX System, SB800 as master flash on-camera, SB910 off-camera slave flash at ½ power, Extra Large Rogue Flashbender bent to light my subject only.

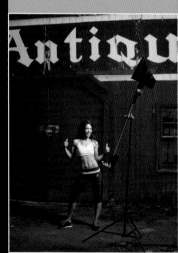

Real world shooting: the headshot

A professionally taken headshot is easy to do just about anywhere. I've lugged my gear up many flights of stairs, been in freight elevators, and been on the upper floors of high-rise offices taking this type of shot. In this shot I have three lights: main or key light, hair light, and background light. While it may seem daunting at first, the setup is simple and easy to execute. You'll need some practice, so find someone willing to sit for you or get out your foam head and set aside some time. While there are a great many variations on the gear used, the basic setup and resultant shot is here for you to study and use for reference.

Nikon D3, 50mm 1.8 Lens, ISO 200, 1/125 sec. at f/5.6
Main light: SB910 at ½ power, Large Rogue Flashbender with diffusion panel
Hair light: SB800 at ½ power, Large Rogue Flashbender with diffusion panel and gaffer tape to create a strip light
Background light: SB800 at ½ power, Rogue Grid with yellow gel and 25° grid installed

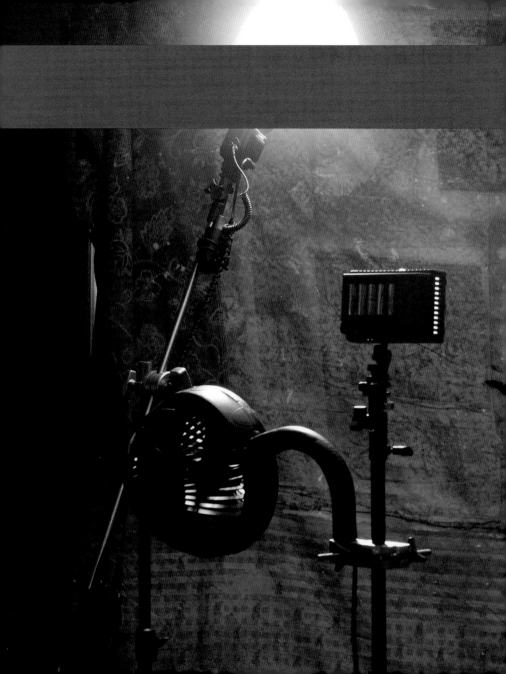

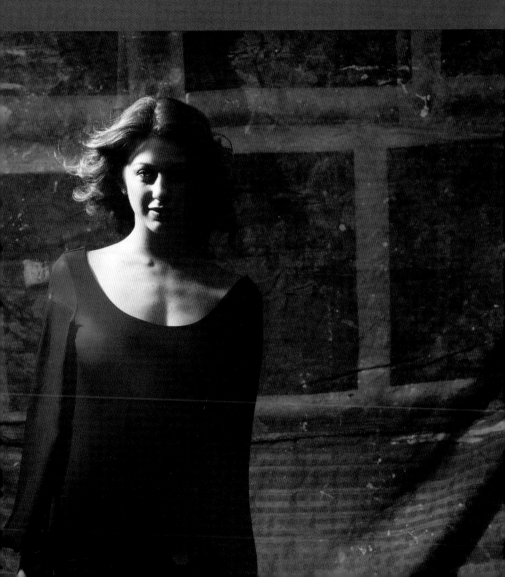

CHAPTER 5 THE HOME STUDIO

The tabletop studio

Being able to shoot in a studio situation offers you complete control and the ability to make global or finite adjustments to your lighting and composition. Studio lighting requires some room, but you don't need a huge professional space: just a small room will suffice.

The tabletop studio is probably one of the best ways to learn about the quality and physics of light. Set this up in your home in a spare room, basement, or garage, and take the time to get to know and understand how flash and flash modification works. With the ultimate portability of small flash photography, it's no problem to set it up and break it down the same day.

The tabletop studio also allows you to work in a small confined area. The size and scale of small flash photography gives you the freedom to incorporate your equipment into even the tightest spaces. Backdrops can be changed easily. Lighting gear—reflectors, tripods, lightstands, and so on—can be maneuvered around a small area to achieve great results. The tabletop studio is perfect for shooting products, online auction images, or simply for photographing subjects in a still environment. Place the studio next to a window and not only will you have natural light

Nikon D3, 60mm Micro Nikkor lens, ISO 200, 1/60 sec. at f/8. Main light: SB800 at ½ power, shoot-through umbrella. Back light: SB800 at ¼ power, black foam paper for flag.

BASIC HOME STUDIO
The basic home studio may look something like this. I set this area up in my small office space above my garage. You only need a little room to work. In the image on the left, shot with this setup, I used two speedlights.

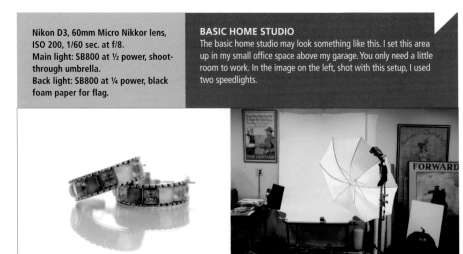

but also you'll be able to mix lighting: daylight and flash. These are also perfect afternoon projects. Take a few pieces of fruit in a bowl, use a wall or sheet for a backdrop, and begin your exploration of light.

Equipment and materials

So, just what do you need to get started setting up your home studio? Here's a guide to the basic equipment and how it can be employed:

Table

• Dining room tables are usually perfect in size

Note
Shooting tethered

While not everyone owns the necessary equipment to shoot with their camera tethered (attached) to a computer, it is a great way to view images and make corrections immediately if you have a laptop that you can position near to your camera or have a shooting space near a desktop computer. Programs such as Capture One, Lightroom, Adobe Bridge, and Aperture all allow you to shoot tethered, and many manufacturers have the option in their proprietary software. You'll need to purchase a cable long enough to give you some freedom of movement, but this small expense is worth it in exchange for having the ability to see (and proof) your work instantly.

and there is enough space in the room itself to allow you movement and placement of a tripod and a few lightstands.

• Kitchen table or counters offer smaller spaces to work in, but for shooting kitchen-related objects it can be the perfect spot.

• Basements and garages make great locations for your studio since there is usually enough room to set up a card table or a plywood bench and shoot while not disturbing anyone in the rest of the house.

Backgrounds

• The walls of your home can work perfectly and are the cheapest solution. Choose a colored wall, set up your table and still life, and shoot.

• Velvet: any color is ideal since the fabric absorbs light and will not reflect it.

• Satin or silk: works well as shiny backdrops that will reflect light; skim light across this material to highlight it.

• Place a white sheet over the window to diffuse hard light; be forewarned that you need to light white separately in order for it to remain white.

• Felt: black felt is perfect for a black backdrop since the felt will absorb all of the light.

• Seamless paper: the choice of many professional photographers, it can be purchased in 5ft (1.5m) or 9ft (2.7m) rolls and comes in a bevy of colors.

• Commercially produced muslin backdrops can be expensive, but are worth the investment as they come in a range of colors and styles, and are long lasting. A gel on a separate background light can be used to change its color.

Reflectors

• Mirrors: great for simple still life projects and give bright, strong contrast.

• White foamcore (foamboard): available at craft or office supply stores, foamcore boards come in a range of sizes and can be cut for any need. Reflectance is good and they can withstand long use. Advantage: initial cost and replacement is inexpensive.

• Aluminum foil: found right in your kitchen so it is the least expensive. Reflectance varies depending on the side you choose; one side is flatter than the other. Roll out two pieces to cover a 20 x 30in. (50 x 76cm) foamcore board and tape the edges and seam with shipping tape for a silver/white reflector. Crumpling the foil before installing removes some of the reflectance and changes specularity, or its reflective value.

• Painted wood or plywood: good reflectance depending on the color it's painted. Gloss white is the best for reflectance and durability. Painting can be messy but also allows you to change colors at will so you can create your own backdrops or use as a colored reflector to add a tint to the image.

• Commercial reflectors: products made by California Sunbounce, Lastolite, and Westcott will be more expensive but also offer more accessories. A 5ft (1.5m) round collapsible reflector will be translucent and have a cover that gives white/silver/black/gold sides. You can diffuse or reflect the light. In the case of the California Sunbounce or Lastolite Tri-Grip, you can purchase a clamp to attach the reflector to a lightstand; in the case of a collapsible round reflector or foamcore board, you'll need a simple hand spring clamp, available at any home center or hardware store, to attach it to a lightstand.

Colored reflectors

• White will reflect soft shadows.

• Silver will reflect harder shadows with a touch of contrast.

• Gold will add a warm tone to the image. Gold is best used on people with dark skin or to add warmth. Be careful, you may like the warm tone on your LCD screen, but then spend time removing that tone when your images are viewed on your computer.

• Silver/gold or zebra stripe is meant to be a compromise that adds just a touch of warmth and contrast.

• Black will subtract light, so it's reflective value is the least.

Tips
• *Know your gear. This allows you to set up, shoot, and breakdown quickly.*
• *Keep an area clear for walking around and adjusting gear.*
• *Make sure there is enough room for other people in the room.*
• *Tape anything loose that may break or form a trip hazard.*
• *Get and stay organized.*

Putting it all together

The tabletop or home studio is a simple way to explore light in all of its shapes and forms. The convenience of setting up in your home on a rainy day or in the middle of winter cannot be overlooked. Having the ability to manipulate your light and see its values and contrast, and add a reflector or even a second light, gives you more freedom in your photography. Backdrops are easier to set up and store, as they are smaller and can be as simple as a sheet from a bed, or a blanket, a drape, colored foil, or just a painted wall. Books from a nearby shelf are handy as props or to give a subject a height boost on the table or chair. Scissors, tape, elastic bands, pencils, pens, and so on are not only readily available, but are also great subjects to shoot. Chairs, stools, couches, and coffee tables all offer support and shooting surfaces for you to explore.

The home studio also transfers to shooting on location. Shooting on location offers the ultimate in tabletop experience. Often working quickly in busy places and during the worst times of day, like the breakfast, lunch, or dinner hour, the experience gained by shooting in a home tabletop situation allows many photographers the chance to transfer that knowledge to working in the field. Producing great results under time and space constraint is the benefit of setting up and learning in the convenience of a home studio.

SHOAL
This image was lit from underneath with a single speedlight. The blue surface is the fabric of a beach chair and the fish are just the candy you buy at the local store. An exercise in graphics and color, this shot was executed in about 10 minutes, the most time spent was in arranging the fish.

Food shoot

In this simple two-light food shot, I used a Nikon SB910 into a Photoflex reflective umbrella as the main light. The umbrella throws and scatters light, but here in the dark dining room I wanted a lot of light from the edge to help keep the background dark.

The second light is a Nikon SB800 with a Rogue 45° Grid. This backlight skims detail light across the top of the hamburger bun, fries, and cups of condiments. This light adds highlight detail on the rear and helps to draw your eye from the "hero" or main food item to the other food on the plate.

Nikon D3, 60mm Micro Nikkor lens,
ISO 200, 1/125 sec. at f/7.1.
Main: Nikon SB910 at ½ power, Photoflex convertible umbrella.
Back: Nikon SB800 at ½ power, Rogue 45° Grid

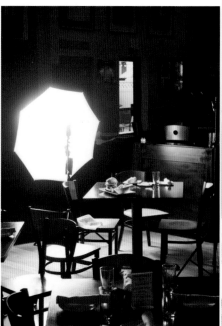

Choosing lenses

When setting out to purchase lenses for your kit, buy the best you can afford until you can afford better. Professional constant aperture lenses will set you back in the wallet, but don't let that discourage you from getting the best you can.

One of the best lenses in my kit is the Nikon 50mm 1.8 D, which is an older design that I took off my F100. It is sharp, small, lightweight, and agile. Whatever lens you choose, research its strengths and weaknesses so you know before a shoot what to expect.

Wide-angle

Your lens choice for your home studio is just as important as choosing what subjects to shoot. Every lens sees the world differently: this is called

Field of View (FOV). The FOV of a 12–24mm wide-angle lens is going to bring more of the world into view. Wide-angle lenses are rarely used for tabletop photography except in perhaps taking a behind-the-scenes reference shot. The wide-angle lens also allows more depth of field into the photo even when shooting at wide open or large apertures. The FOV of the lens is so broad that even at an aperture of f/2.8, much of the background will be in view. This may or may not be the effect you want to achieve. You'll need to get in very, very close in order to exclude much of the background, so while they are not recommended, they do have their uses.

Mid-range zoom

The mid-range zoom or even prime lens (lenses that don't zoom) work well in this situation. A suitable lens in the 24–70mm range will give a

WIDE-ANGLE

A wide-angle lens sees a lot of the world and is well suited for wedding and event photography where you need to get the whole wedding party in shot, or for dramatic landscapes. It can be used for environmental portraiture as well, just be wary of the distortion caused by its extreme field of view.

good field of view and depth of field, allowing you to shoot at working apertures of f/5.6 to f/11 or beyond and get plenty of sharpness in the image from front to back. The lens can be zoomed in for close-ups and then zoomed out for a broader view. It is important to get into the habit of taking a behind-the-scenes or setup shot to keep in a reference folder. Once you have a few of these on your computer you can continually go back and study them for future shoots or to understand what you did right, or wrong, and how you can correct it or expand upon your technique.

Telephoto

A telephoto lens in the 70–200mm range is a good choice for still life and portrait work in the home studio, as filling the frame with your subject is easy when you zoom in to 200mm. At the same time, you aren't going to be inches from your subject's face (for portraits), which allows a relaxed and comfortable working distance between model and photographer.

Depth of field becomes more of an issue though, as it decreases at longer focal lengths. For portraits this can be beneficial, as you can isolate your subject and make the background go out of focus. If you combine this with a subject that's close to the camera, then depth of field is restricted even further, meaning you may have a shallow depth of field even at apertures of f/11, f/16, and f/22.

Dedicated macro

The dedicated macro lens in the 50–105mm range is a favorite for this type of photography. These lenses are designed for close-up work so they are incredibly sharp and have great contrast and color rendition. A lens of this type has the ability to get in close or stay far back, increasing or decreasing depth of field accordingly and allowing a broad range of control. But remember, macro lenses don't zoom, so you need to move your feet or tripod for frame-filling, compelling images.

The diopter

Diopters are like great magicians: superb at the art of sleight-of-hand trickery. They are designed to decrease the focusing range of a lens. They are supplementary lenses that attach to the front element of the lens and increase the focusing length: so a lens designed with a close focus distance of, say 3ft (1m), can get as close as 6in. (15cm) with a diopter attached. Canon makes the 500D Diopter with a 77mm thread for attaching to longer lenses such as a 70–200mm. It doesn't matter what make lens you're using, as long as the diopter fits the front thread. You can use a Nikon 70–200mm lens with a Canon 500D Diopter and go from a focusing distance of 5.5ft (1.7m) down to 18in. (45cm). Getting in that close with a lens and diopter combination means that aperture choice for depth of field is important to get the final result you want.

Extension tubes

Extension tubes are an inexpensive alternative to purchasing the diopter or dedicated macro lens. They are rings that fit between the lens and camera and put a specific distance between the two: typically 12mm, 20mm, 36mm, or any combination of the tubes to increase the distance to a total of 68mm. There are no optical tricks or sleight-of-hand happening in front of the lens. Extension tubes add distance between the rear element of the lens, which causes the normal focusing distance of the lens to be shortened. Focusing distance and depth of field are affected by the installation of the tubes, but not

optics. You can effectively add an extension tube to any lens and get it to focus closer. You can turn a simple 50mm lens or your 70–300mm telephoto into a macro lens. Because depth of field is affected, you'll need to work on a tripod and take care to focus carefully on your subject, use a cable release so everything remains steady, and check your LCD for exposure and depth of field. You may find yourself shooting at working apertures of f/16 or f/22 instead of f/5.6 or f/11 to compensate for the changes in depth of field.

The still life studio

In our still life studio the sidelight from the window is diffused by a white sheet, a tabletop forms the backdrop. The still life is placed on the table, and one main light is setup on a lightstand, with a reflector ready to use on a chair. The camera is mounted on a tripod and the laptop is ready to have the camera attached.

If we start with our hotshoe flash in Manual Mode at ½ power and choose a working exposure of 1/125 sec. for the shutter speed, f/5.6 for the aperture and depth of field, ISO 200 for image quality, but then discover on the LCD that the image is overexposed, what do we do?

Four choices await us as we stand over our cameras. Changing the flash power from ½ to ¼ may be the first step, especially if we want to maintain those current camera settings. So we can see that the exposure triangle that has now changed to the exposure square lets us have an additional adjustment for our final image. Is there one choice over another that is better? No. The decision is a creative one.

You can just as easily change aperture to increase or decrease depth of field, change shutter speed to change the amount of light over time, or adjust ISO. The choice is up to the photographer, but by adding controllable light we add another choice to the equation.

> *Note*
> *The modeling light*
> *One of the drawbacks to using small flashes is the lack of a "modeling light." On larger studio strobe lighting there is a light that stays on all the time, unless you turn it off, that shows you how the light is going to hit your subject. The modeling light is very useful in positioning a strobe to get maximum effect. Hotshoe flashes don't have this capability, so the photographer is relegated to setting up, shooting, and checking the LCD on the back of the camera. But not having the modeling light is also a good thing, as it helps to teach us how to use and expose for our light.*

The studio

Here's a simple view of a setup in a dining room. The sidelight from a window is diffused by a white sheet, or can be shut down by closing the blinds. The tabletop or wall is the backdrop.

Nikon D200, 18–70mm lens, ISO 200, 1/60 sec. at f/5, camera on Program Automatic, flash in TTL Mode, bounce flash with a second Spinlight 360 bounced off ceiling/wall intersection.	**BOUNCE FLASH** When starting out, keep your still life images simple. A bowl of apples for this entire set of images illustrates each technique. Start small and slow with an easy technique like bounce flash, here using the Spinlight 360 to aim my bounced light where I want it.

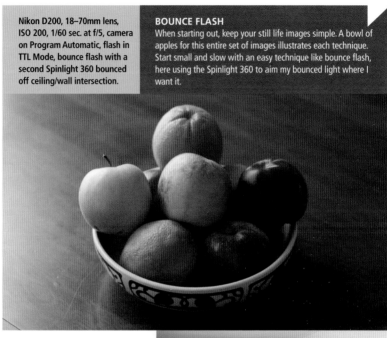

Working the light

Bounce light

Bouncing your flash off the camera is an easy way to start. Soft light falling on your subject can be achieved easily by putting your flash on a lightstand and just aiming it toward the nearest wall or ceiling. However, bouncing flash is an inefficient use of light as so much light is lost in sending light out toward a wall then sending it back to the subject. The resulting base exposure may have to be adjusted to allow for such a loss of light.

SPINLIGHT 360
A new alternative in the bounce flash marketplace, the Spinlight system allows you full creative control of your bounce light. Whether working in a home studio or on location, the Spinlight allows you many variations to control your light as in the photos on the next page.

Photo courtesy of Spinlight 360

Nikon D3, 60mm Micro Nikkor lens, ISO 200, 1/125 sec. at f/8. Nikon SB910, Manual Mode at ½ power bounce flash

SPINLIGHT 360 BOUNCE FLASH
Just by bouncing my light off the wall/ceiling combination, I literally turned the room into my light source for this shot. I was able to control where I bounced the light and then let it fall softly on the apples.

Nikon D3, 60mm Micro Nikkor
lens, ISO 200,
1/125 sec. at f/22

SHADOW DETAIL
I used direct flash here to make a point: just by getting the flash
off of the camera you dramatically change the look and softness of
the light. Here the light quality is still hard and unforgiving, but it is
softer than if this was direct flash from on top of the camera.

Umbrellas

The convertible umbrella should be in every photographer's kit. The versatility of this simple and inexpensive modifier as main light, back light, edge, and rim light is outstanding. The umbrella is one of the best and simplest pieces of gear in the marketplace. You'll have to lose any suspicion surrounding opening an umbrella inside, though, as you'll be opening and closing them a lot! When you use the umbrella in the reflective style—the way it was first meant to be used—it gives you a nice, clean, soft light with a touch of cool contrast. Set the umbrella and stand in the traditional 45° x 45° portrait orientation and take a test shot. You can modify the light even further by leaving the plastic diffuser on or off. Leaving the diffuser off will add contrast, while leaving the diffuser on will add a touch of warmth to the image and soften the light just a touch more.

SCATTERED LIGHT

A reflective umbrella produces a very soft light, but it is also very inefficient in that is scatters light all over the place with little control. Master the reflective umbrella and you can master any lighting modifier.

Nikon D3, 60mm Micro Nikkor lens,
ISO 200, 1/125 sec. at f/5.6

Shoot-through umbrella

After shooting in the reflective style, remove the black cover and use it in the shoot-through style. The light from the shoot-through umbrella is a bit warmer and less contrasty than the reflective umbrella. This lighting is soft and the main point of light emitted from the flash can be aimed. The reflective umbrella throws and scatters light; the shoot-through umbrella does the same, but you can aim the central part of the light to the right or left or into a reflector so you are feathering the light to one side or another. Feathering the light allows you to direct the light and actually soften it by lighting the subject with the spill light from the umbrella and not the central core of light from the center of the light source.

DIRECT SCATTERED LIGHT
A shoot-through umbrella offers unlimited scattered light and soft, soft shadows. It's ability to be feathered, or directed, from one side of a subject to another makes it the perfect choice for any kit.

Nikon D3, 60mm Micro Nikkor lens,
ISO 200, 1/125 sec. at f/7.1

Softbox

The portable softbox is another tool that should be in the small flash photographer's kit bag. The Lastolite 24 x 24 Ezybox Hotshoe is designed with the small flash photographer in mind. It folds and stores in a nicely designed bag that accepts the mounting hardware as well. The softbox controls light spillage. This means that all of the light is concentrated out of the controlled box. Just like the shoot-through umbrella, you can control the light and light spillage by directing the softbox to one side or the other, feathering the light for effect.

FEATHERING THE LIGHT
Softboxes allow you to fully control the spread of light. Feathering the light allows you to also control aperture and depth of field. Pointing the light source directly to the subject will offer more light, hence, more depth of field as opposed to moving the softbox to light from its edge.

Nikon D3, 60mm Micro Nikkor lens, ISO 200, 1/125 sec. at f/7.1

Grids

Softboxes can also accept grids. Gridded light is defined by direction and sharpness. The light becomes focusable and direct as it exits the softbox. Unlike an umbrella, which scatters light, a gridded softbox becomes a focused beam. The contrast increases and the light direction also becomes direct. Light quality is affected as the light is closed down and contained within the grid.

Grids are available from a variety of manufacturers, but no matter the origin, grids allow full focusable control of the light from this large source.

FOCUSING
The grid allows you to focus and sharpen the light and create deep shadow detail. But you should pay attention to where you are focusing your camera. To create an image with good depth of field, focus at least $1/3$ into the subject. Here, I focused on the edge of the closest orange and apple so I could get as much sharp as possible in a small space.

**Nikon D3, 60mm Micro Nikkor lens,
ISO 200, 1/125 sec. at f/7.1**

Snoots, grids, and gobos

Snoots, grids, and go-betweens (gobos) mold and shape light. Snoots close down the light and direct hard beams of light where you aim them; grids sharpen and narrow the light into a tighter spread of light and need to be aimed carefully; gobos (or cucoloris or cookies) are anything placed in between the light and the subject to create a pattern (usually on the background), with the aim of adding depth, dimension, and interest.

A snoot will give a direct beam of light but is broader than a grid. The size and length of the snoot will also affect the overall spread of light. A shorter snoot, say 6in. (15cm) will have a wider spread of light than a 12in. (30cm) snoot. Use this time while experimenting with light to not only explore light placement, but also the

DEPTH OF FIELD
Each speedlight modifier has its own properties. Some are softer or harder than others. The hardness of the light coming out of the modifier directly affects aperture and depth of field. In this photo, an aperture of f/16 was needed to get a good exposure as the light from the snoot is both hard and very bright.

**Nikon D3, 60mm Micro Nikkor lens,
ISO 200, 1/125 sec. at f/16**

spread of light by moving your snoots, grids, and gobos to different positions and seeing the difference in light quality.

A grid will produce a tight beam of light, for example, so care needs to be taken when aiming as it may miss the target because it is so concentrated. Some commercially produced grids have multiple attachments to take the beam of light from a spread of around 45° down to 16°.

A gobo or cookie can be anything placed between the light and the background for creative effect. Commercially available products offer a wide range of shapes and styles of patterns. Selections from Rosco go from round top windows, to shaped windows, to irregular shapes to add dimension to the image. But anything can be used as a gobo: venetian blinds, an old window frame, or foil with shapes cut into it as in the photo shown here.

HARD LIGHT
The light on the fruit here is harder than the shot taken with the snoot. The grid is like a spotlight on your flash and it tightens the beam spread of light. Grids can be used effectively as back lights and even as main or key lights in portraiture. The effect of gridded light also adds to the depth of field.

Nikon D3, 60mm Micro Nikkor lens,
ISO 200, 1/125 sec. at f/16

Nikon D3, 60 mm Micro
Nikkor lens, ISO 200,
1/125 sec. at f/22

THE GO BETWEEN
By putting something in between your lightsource and subject,
you create a gobo or "go between." Here, I used a piece of tin
foil with slits cut into it, giving splattered light with just a touch
more light in one spot. You see these used in TV interviews. Behind
the interviewee is usually a small pattern of light illuminating the
background. This is a gobo attached to one light source and helps to
give a bit of added depth and separation.

Duping

Duping refers to the process of photographing anything on a flat surface; old photos or posters behind glass frames; stamps in sleeves; old advertisements that are too big to run through a scanner; or prints that can't be removed from behind glass. Small flash photography is uniquely suited to this, as small flashes are portable and can be taken on location for this kind of work. When photographing artwork or large objects on the wall, cross light your subject so the umbrellas and the glare of framed glass are not seen in the final image. Once photographed, the image can be manipulated in software such as Adobe Photoshop: cropped, cleaned, color corrected, edges repaired, etc., and then sent out to print.

Tip

Take you time when setting your camera up to shoot. The camera sensor and artwork should be parallel and on the same focus plane so image manipulation and straightening later in postprocessing is kept to a minimum.

ORIGINAL PHOTOGRAPH
The original photo of this turn of the 19th century gentleman was faded and mounted on board many years ago. Removing the image from the frame was deemed impossible, so I photographed the image in the frame, on the wall, and in the owner's living room using two speedlights and reflective umbrellas.

COPIED AND CORRECTED
After having been color corrected and run through Photoshop, the finished image looks not only better than the one in the frame but probably better than the original. Once printed, the photo now resides on the wall and the original in a dark, dry place to keep it intact.

Two light setup

The copy stand is another way to do copy work. Small stands allow the work and the camera to remain parallel and flat so extensive image correction later is not necessary. Copy stands allow you to focus and position the camera and lens combination for perfect results, with the images usually only needing color correction, cleaning, and minimal cropping. You can cross light the image being copied to get full even light on the stand for clean shadowless light. During any one of these copying shoots, care should be taken to fill the frame as much as possible to allow for full resolution images to be delivered to the client or to the lab to retain ultimate image quality.

COPY STAND
This old Pentax copy stand is perfect for small reproduction work. It does automatically what you need to do in the field: keep your subject and film or sensor plane perfectly parallel.

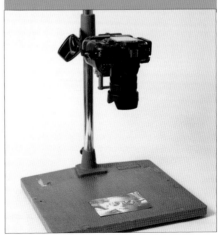

Stopping motion

The flash duration of small flashes can be as brief as 1/40,000 sec. depending on the total flash output. This extremely short flash duration makes them uniquely suited to high-speed, motion-capturing images. The setup is simple: place a waterproof plastic sheet over your shooting surface to protect it, fill a glass with water or other fluid, choose an item to drop into it, then focus the camera and fire away.

In the fluid-filled jar or cup, place a pencil point and focus your camera on that and then turn your autofocus off. When you do this, you focus on a certain point in the image and allow the subject to drop without your camera continually hunting for focus. Use a cable release so you don't touch the camera any more and avoid any camera movement. Use a flash cord or radio trigger that allows you a synchronization speed above 1/250 sec. Your camera manufacturer's flash cord will work as

you want a very fast shutters speed. That's about it. You can get really creative here, but let's test this out and see the results.

Shooting high-speed frames in photography requires the use of high speed synchronization. This means you'll need a few specialty tools to conduct this operation.

• Make sure the high speed synchronization (HSS) feature is enabled in your camera. Review your manual for your specific camera/flash combination.
• Use a dedicated off-camera flash cord, as all TTL and high speed sync adjustments will travel from your camera to the flash.
• If your camera doesn't have a triggering mode such as Nikon's CLS, you'll need a dedicated triggering system such as the Radio Popper PX or Pocket Wizard Flex. Both of these systems will handle high speed sync well for most camera makes and models.

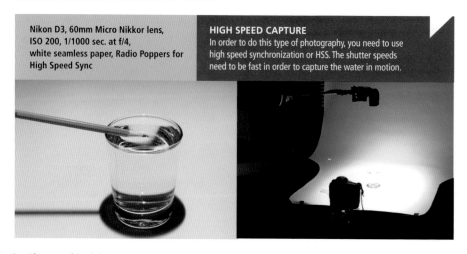

Nikon D3, 60mm Micro Nikkor lens, ISO 200, 1/1000 sec. at f/4, white seamless paper, Radio Poppers for High Speed Sync

HIGH SPEED CAPTURE
In order to do this type of photography, you need to use high speed synchronization or HSS. The shutter speeds need to be fast in order to capture the water in motion.

Water droplets

Choosing the final image is always tough. I chose this one as I was intrigued by the way the water bounced out to the side of the glass. I also liked how the backdrop worked. This is a great setup for product photography too, as the white paper acts as a built-in reflector to add fill light to the bottom of anything sitting on top of it.

ISO 200, 1/1000 sec. at f/4, white seamless paper, Radio Poppers for High Speed Sync

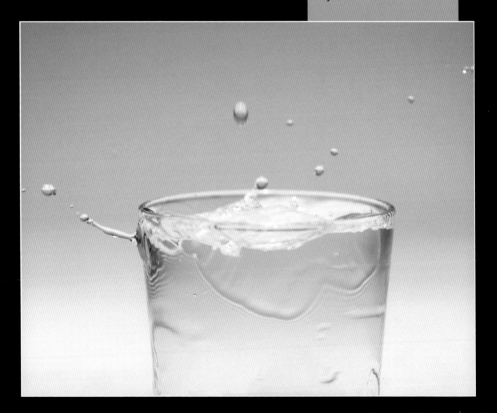

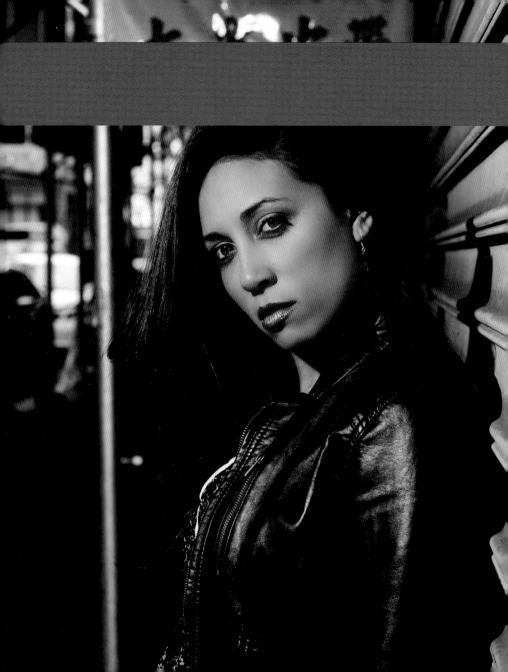

CHAPTER 6 PUTTING IT INTO PRACTICE

Flash on the move

One of the benefits of small flash photography is portability, which means you can use the flash in your kit bag along with a flash cord, or store a pair of radio triggers so that you can use your flash anywhere at anytime.

Whether you are using on- or off-camera flash, there's something for every photographer, from the landscape shooter, to the portrait shooter to the product shooter, and everyone in between. You can use Nikon's Creative Lighting system or dedicated radio triggers, or even just the test button on the back of the flash.

A basic daily travel kit may look like this:
- A small waist or fanny pack. Choose one that isn't branded and it won't scream "expensive

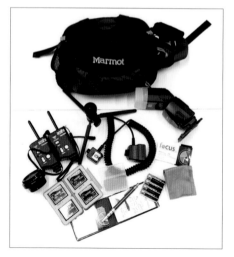

camera gear inside!" while you're out shooting.
- A flash with stand and diffuser so you can place it in crazy locations.
- Gels for color correction or color enhancement.
- A mini tripod just in case.
- Flash cord.
- Two radio triggers: one for the camera, one for the flash.
- Extra batteries.
- Pen and paper.
- Business cards.
- Cleaning cloth.
- Storage cards.
- 12mm extension tube with lens and body caps, just in case: I shoot a lot with a 50mm lens and the 12mm extension tube helps me get just a bit closer.

Keeping a kit handy with you will make you shoot more. How many times have you been out walking or driving and spotted something you thought would be great to shoot? Now what? Go home, get your kit, go back and then someone parks in front of your perfect shot, it starts to rain, or the light has changed? Bring along a small kit and you'll be amply rewarded with more and better images, because as we all know the more you shoot, the better you get.

A sense of movement

While in Central Park, NYC scouting locations for a workshop, I wound up at the carousel. I was wearing my small waist-pack kit. I opened it and got set up. I wasn't looking for a particular shot or really anything that dramatic. I was looking for locations, but had an idea. I wanted to show the versatility of carrying a small kit, wanted to show movement, and wanted to

highlight off-camera flash. I opened the kit and went to work. The nice thing about its size is that it is fairly inconspicuous and easy to unpack and repack to hit the road. I took a test shot to see just what I wanted.

It wasn't what I was hoping for. I wanted to darken and show some motion in the background as the first test shot was bright and clean and had harsh shadows. By using

TEST SHOT
Dark shadows and bright highlights on the carousel horses give a static, bleached appearance.

Nikon D3, 35–70mm lens, ISO 200, 1/250 sec. at f/5.6

BLURRED ACTION
Raising the flash high and left, and adjusting the shutter speed blurred the background horses while keeping those in front crisp.

Nikon D3, 35–70mm lens, ISO 200, 1/20 sec. at f/16 Flash Manual Mode ½ power direct, no diffusion

exposure and some creativity, I moved my light to the left and raised it. I installed the Pocket Wizards so I wasn't tied to my camera with the cord. The cord is great for fast setup and just holding the flash off to one side. But I had time and used my location to my advantage.

I adjusted my shutter speed to give me some motion in the background and then adjusted the aperture to reduce the background light, while allowing enough light to expose the foreground horse of the iron gate. The juxtaposition of the moving horses on the carousel in the background to the still horses is what attracted me to the image. Holding the flash and Pocket Wizard combination high and to the left gave me enough light on the foreground and barely any visible drop shadow on the ground in front of the carousel. With a shutter speed of 1/20 sec., there is motion in the background, while the blast of flash lit the horses on the gate perfectly even at f/16.

The color of sunrise

In the photo below, the camera was set on a tripod for a long sunrise exposure. The exposure was set for the sky so that it wasn't overexposed or washed out. Then, as the sun broke the horizon, I used a Nikon SB800 and depressed the test button as many times as possible until the batteries ran out. This enabled me to light the rocks and seagrass in the foreground. Utilizing just the flash I carry with me on a daily basis without a lightstand or trigger system or light modifier, I was able to capture foreground and background in the image. Using a tripod enabled a long exposure of 20 seconds. The long exposure allowed for plenty of light to get in to capture the dark, early morning glow and gave me enough time to depress the test button on the flash to illuminate the foreground. Getting out early is a must for landscape photographers and bringing a flash along can help to enhance any image.

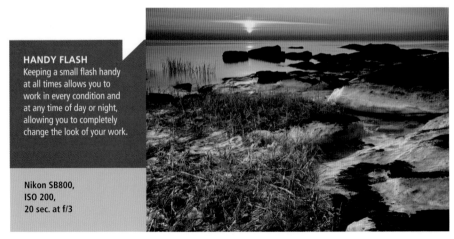

HANDY FLASH
Keeping a small flash handy at all times allows you to work in every condition and at any time of day or night, allowing you to completely change the look of your work.

**Nikon SB800,
ISO 200,
20 sec. at f/3**

Evening illumination

Evening is a great time to get out and shoot. This is especially true when traveling. The best time to shoot is when everyone is either asleep in the morning, at dinner, or asleep at night. While out one night teaching a photography class, we happened upon an iconic site in the town we were working. I wanted to teach a bit about off-camera flash and gels. We set up a small flash on the left of the statue behind the bushes and gelled it with a Full Cut CTO gel to balance the 5500K setting of the flash to the 3200K temperature of the warm lighting on the town hall.

ISO 400, 1/30 sec. at f/4, WB Daylight, Nikon SB910, Manual Mode, ½ power White Balance Tungsten/Incandescent, Full Continuous Orange or CTO gel on flash

STEADY SUPPORT
Shooting at night presents a few problems, including using a tripod to get a good exposure at a long shutter speed. But also carry the small stand your flash comes with and you can position your flash anywhere on the ground or wall or high up on a shelf to place light where you want it.

Low level light

Shooting in low light or even at night presents a host of problems that can be overcome if you understand exposure and how to use the exposure square: shutter, aperture, ISO, and flash output.

While out shooting at night in New Haven and looking to do something creative that I've not done before, the model and I stopped in an alleyway and tried a few different looks and ideas until this one crossed my mind. I wanted to bounce the flash and get light in several different areas of the image while only using one light source. Making one light behave like multiple light sources will really tax your ability as a photographer, but by placing the flash directly behind the model and close to her back, that's precisely what has been achieved here. As a bonus, the raindrops are actually condensation drops falling from an air conditioner above us!

ISO 1,000,
1/60 sec. at f/4

LIGHT PLACEMENT
You should always consider creative light placement when using small flashes. Think about your shot before you take it and how you can make it more interesting by adding light to the sides or back of your subject.

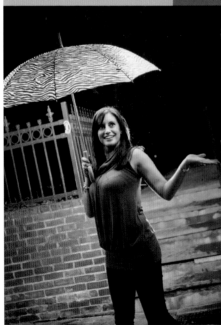
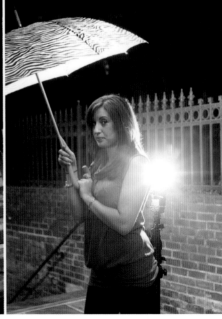

With a single speedlight we got four distinctly separate lighting effects:

1. Backlight on the steps and brick wall behind the model.

2. Backlight on the model herself.

3. Hair and separation light as the light bounced into the umbrella.

4. Main light on her face as the light hit the inside of the umbrella and followed its shape to come over the top of her head and fall on her face as a main light.

The dark of night

Back out for a night shoot, I was looking for something different again and wanted to use what was available and easy to shoot. The bus stop on the corner looked like a great spot to shoot. I placed the model in the bus stop and posed her as if she were waiting for a bus.

Using one flash and whatever other light was available to me on the street corner, I positioned my speedlight outside the glass while my model posed inside.

This is a common technique that will give great results, and means that you have the ability to make your scene look as though it is lit by an auxiliary source of light on the street when actually it is being held by an assistant.

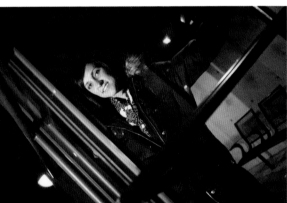

MODEL PLACEMENT
Consider placing your subject in a creative location. With small flashes and the LCD screen on the rear of your camera, you have the ability to put your subject and light just about anywhere at any time.

ISO 800, 1/30 sec. at f/2.8

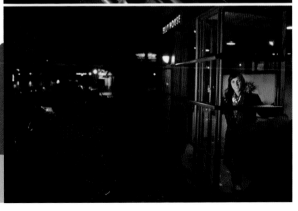

Classic car drama

While on assignment to shoot a few cars for a local magazine, I chose to use off-camera flash to add some depth and dimension to the automobile images. Sometimes this works for you or against you. The editor didn't choose any of the shots here, which happen to be the most creative and fun. When challenged to provide imagery that is dynamic and shows depth and detail, you must be prepared to work at all times. I study magazines in an attempt not only to keep fresh on lighting and what is popular, but also to try and bring these techniques into my own work and also help others to do the same.

These images are outtakes from a shoot on classic cars. The Delorean is classified as a classic and can be fun to shoot. With the gull wing doors, getting creative wasn't that difficult. By placing one small flash on either seat inside the car and one flash behind the camera, I was able to light the inside and out simply and in only a few minutes. Shoots like this are fun as you can scout and use grungy locations for that industrial look. This worked especially well with in an old shipping depot.

Once the initial image that was imagined was captured and the owner of the car loved it, I set about to shut down some of the ambient light around the car and darken it and showcase the interior and just a hint of the stainless steel body. By increasing the aperture, the ambient light was closed down and the light surrounding the car darkened. In small flash photography there is a theory that shutter speed controls ambient light and aperture controls flash exposure. Here, in this image, that theory has been proven wrong.

The shutter speed remains a constant 1/250 sec. as my Pocket Wizard Plus IIs won't synchronize with my flash beyond that shutter speed, so I chose to close down the aperture by 1 full stop from f/11 to f/16 and look at the dramatic difference in the image. The light has been reduced by the aperture, not by shutter speed. As in all things in photography, there are no set constants for exposure: it is literally what works at that point in time. Take the theories and ideas and the constants and the rules that you already know and break them. By closing the aperture down by one stop, the ambient light was completely shut down and the overall look and feel of the image changed.

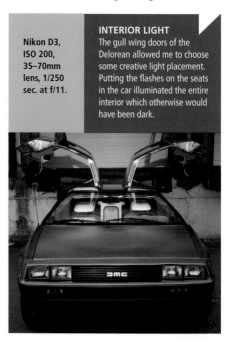

Nikon D3, ISO 200, 35–70mm lens, 1/250 sec. at f/11.

INTERIOR LIGHT
The gull wing doors of the Delorean allowed me to choose some creative light placement. Putting the flashes on the seats in the car illuminated the entire interior which otherwise would have been dark.

Nikon D3, 35–70mm lens,
ISO 200, 1/250 sec. at f/11.
2 Nikon SB800s, one on either
seat, 1 Nikon SB900 behind the
camera

LENS CHOICE
Compared to the image on the facing page, I
stopped my aperture down from f/11 to f/16, which
automatically darkened the image. Get creative with
your shutter, aperture, and ISO to radically alter the
look of your images.

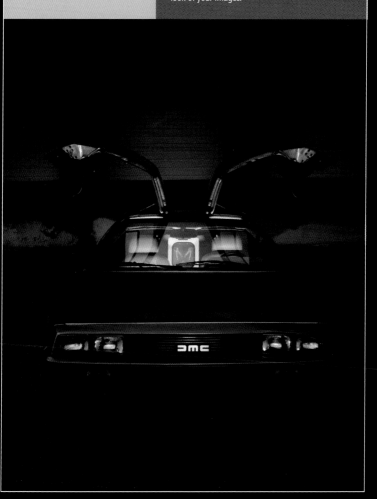

Grabbing a bite

Shooting off-camera flash on location is convenient and fun, except during a lunch hour shoot in a busy, local restaurant. I had to work in between the breakfast and lunch crowd for this assignment, although the crowd never seemed to cease in this restaurant.

Working quickly, I chose a spot that would give a nice dark background to contrast with the white plate and show some detail. The bench in the entrance to the restaurant was the best, and quite frankly the only choice to get the look I wanted since all the tables were still full. I was able to set up and work quickly in the entryway and had the ability to move my main light if someone entered or exited and place it back to where it was to keep working.

To prepare for this shoot, I worked out my lighting setups on my tabletop studio in my home, which allowed me to work out most of the lighting before I actually arrived at the restaurant. Once on location I just needed to make a few adjustments for the conditions to get the shot for my client.

ISO 200,
1/125 sec. at f/5.6,
WB Daylight

WORKING WITH YOUR LOCATION
Working on location provides many challenges to be overcome by the resourceful photographer. Yet great and fun images can be had on the fly as long as you are willing to work around your environment.

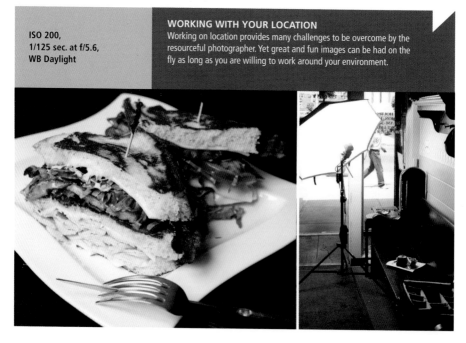

Dragging the shutter

Setting up and shooting on your own tabletop studio not only allows you to figure out your lighting beforehand, so you can work quickly and effectively when under the constraints of a deadline, but it's also a gateway to creativity where you can practice and experiment with ideas and techniques.

In the shot below, the blueberries were placed in a wine glass in front of a colorful piece of fabric and flashed from the right with just a touch of fill flash to highlight the bottom blueberry and capture some motion. There is a bit of motion in the image and it was shot at a fairly slow shutter speed. This technique is also called dragging the shutter.

By using a slow shutter speed and rear curtain synchronization the effect is a bit of movement and then using the blast of flash to freeze that motion. Here, some motion is left in the entire image.

ISO 200,
1/13 sec. at f/4.2,
WB Daylight

FREEZE FRAME
Shape and movement are illustrated here as the light comes in from the side and skims across the blueberries, freezing them in the soda, and movement comes in the form of a slow shutter speed.

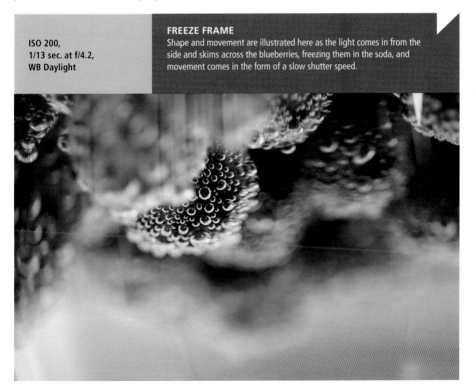

Pack shot setup

In this series of shots, the tabletop studio was employed to complete product photography jobs. A tabletop studio can be set up anywhere using a card table and simple backdrop. Set up in my home office above the garage, the tabletop studio suffices for all types of work. While testing for product photography, I chose a simple setup to light and shoot high contrast aluminum automobile parts as part of a test for the final shoot. The light is directly from above and into a Lastolite 24 x 24 Ezybox. Underneath the parts is a piece of clear glass on top of black felt. Black felt absorbs all the light you put onto it, so it works well under these conditions. Keep the black background about 5ft (1.5m) from the piece you are shooting and depth of field will help the background fall out of focus and become soft so there is very little cleaning or adjusting of the image after you've captured it.

HOME STUDIO
The need to rent large studio space is now not necessary. The home studio is the perfect location for just about any type of photography.

Nikon D3, 60mm Micro Nikkor lens, ISO 200, 1.160 sec. at f/8

Bare head flash

On assignment to shoot a Yale student and violin prodigy, I chose to shoot outside on a gorgeous Fall day. The student met me in front of the Stirling Library on the Yale campus and we shot on a busy thoroughfare. I posed him holding his violin casually in the walkway, used the natural sunlight off to camera right to get some edge light on his left shoulder and side of his face, then I used my SB800 bare head flash off to the left as my main light, thereby balancing daylight and speedlight to get a natural look to the image.

Using bare head flash outside is fun and easy. You'll be surprised at how the light is softer than straight fill flash. As soon as the flash is off the camera, the quality of light changes and is surprisingly soft and manageable. You can use bare head flash to get good depth of field along with using it as a fill light. Here, while it is the main light, it looks like it is natural. The only way to tell is that he looks like he's been separated from the background by the light, which is a side effect of an external light source.

ISO 200,
1/60 sec. at f/10

SUN THROUGH THE TREES
The main light is a single bare head Nikon SB800, and the hair and shoulder light is from the sun streaming through the trees on the right of the frame. The two light sources, speedlight and sun, intermix seamlessly and the bare head flash begins to look just like the sun.

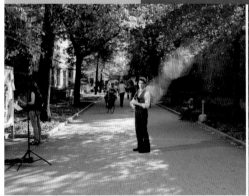

Soft light

Shooting on location is uniquely suited to small flash photography. Commissioned to do a maternity sitting, I was able to get to the second floor bedroom, set up, and shoot with ease. Draping a white sheet over a sliding glass door allowed me to control the backlight and also turn it into a high key setting. Keep a white sheet handy in your kit as it works wonders when shooting natural light in any situation. By placing the sheet over a window, you remove the hard light streaming through and effectively turn the room into a large softbox. If needed, you can also place a light outside the window and pump light in through the sheet to add something more to the image. In this case it was a sunny day and the light in the room, with the sheet over the glass door, was broad, bright, and soft. I set a single SB800 onto a lightstand with a shoot-through umbrella to conduct the shoot. With plenty of ambient light in the room, exposures were set for the foreground subject, which let the background go bright white.

CREATE A STUDIO ANYWHERE
Any room will suffice as a studio, even this bedroom. Don't think you can make great images in cramped spaces? Think again as the maternity shot was taken on location in about an hour.

Nikon D3,
60mm Micro Nikkor lens,
ISO 800,
1/200 sec. at f/5.6,
Nikon SB800, Manual
Mode at ½ power

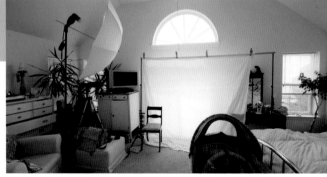

Perfect backlight

While shooting for portfolio in a nasty and graffiti ridden location, I wanted to use natural light and speedlight as fill. The problem with this is that speedlights don't have enough power to overcome the sun. So, without the aid of high-speed synchronization, which allows us to use fast shutter speeds, we are locked into the maximum sync speed our camera will allow, usually in the 1/200–1/250 sec. range. In the image below, the hazy summer sun was over the building in the rear of the scene. Wanting to use some natural light, but realizing that my SB900 wasn't powerful enough to overcome that light, I posed the model so the sun would be at her back, giving me a hair and edge light. I realized, though, that her face might fall into shadow depending on the exposure I set in my camera. So, wanting nice soft fill light but not wanting to blast the model with light, I bounced my flash off the nearest reflective surface: the silver-sided trailer. This setup worked perfectly to get hair and backlight and to give me a soft fill that maintained some level of detail across the entire image.

**Nikon D3,
70–200mm f/2.8 VR lens,
ISO 200, 1/200 sec. at f/5,
Nikon SB900, Manual Mode
at ½ power**

HAIR LIGHT
Hair light is the sunlight coming from over the top of the building. In this case, try using your spot meter to get a good exposure on the subject's face and use flash only as fill light. Here, just by employing a bit of bounce light, the subject pops off the hazy background.

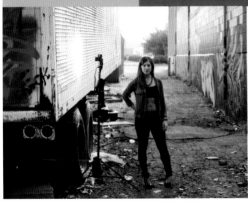

Sculpting light

Always play and explore light and how to light your subjects. Wanting to achieve a high contrast fitness shot in black and white, I set about first finding a model. Once that was achieved, we met in the studio and I chose a Lastolite 24 x 24 Ezybox as the main and only light source directly above the subject. Using softboxes allows you to control the light placement and spill. The spill is the light that exits the edges of a softbox and flows over or beyond your subject. But you can use the spill light as the main light and use it to skim the light over what you are shooting. In this case, the spill light out of the softbox skims along the model's body, exposing the highlights and shadows of his muscular structure. Adding the bar as a prop accentuates his physique under the skimmed light, which allowed me to pose him in some form of movement so his body could be sculpted by the light. Had he been lit directly under the softbox, his features would have been flat and possibly washed out.

Nikon D3,
70–200mm f/2.8 VR lens,
ISO 400, 1/200 sec. at f/8,
Nikon SB900 into a Lastolite
24x24 Ezybox

MUSCLE DEFINITION
The main light from above illuminates the subject simply and allows for a great deal of shadow on his muscular back. Use your light from different angles and skim it across for highlight and edge tail.

Workshop session

The workshop is an important experience for photographers, since they are able to shoot with gear they may not own or are thinking of buying, they get to work with top talent, and they get to see a professional in action and speak with him/her about the business, lighting, gear, etc. Workshops constitute a large part of modern digital photography and attendance at any workshop is highly recommended to further your goals in lighting, equipment, and knowledge. This format is an important part to my business and I run them frequently all around the United States. Teaching photography students is a huge part of the business of photography and in these images the workshop format is showcased.

In the set of images below, a 1950s glamour shot was the theme. One of the great things associated with workshops is the theme. You'll get to see great models and stylists in action and network with them for your own purposes. The workshop is a great way to meet other photographers from all over the world as

**Nikon D3,
70–200mm f/2.8 VR lens**

MULTIPLE LIGHTS
Wrapping your subject with multiple lights and a reflector is a great way to achieve a beautiful result. In this shot the lighting envelops the model, smoothing her skin to enhance the glamorous theme.

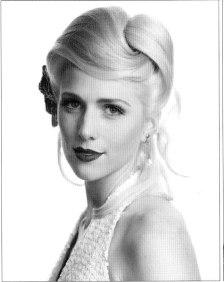
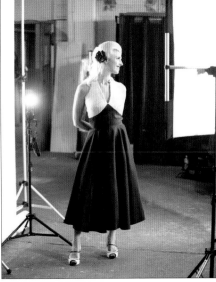

well. My model came styled with her hair and makeup done, and I provided the 1950s style cocktail dress, which I purchased cheaply in a consignment shop. The look and lighting really worked during the session.

The lighting is a simple two-speedlight high-key setup. One light is positioned behind the model with the plastic diffuser attached to give backlight and to turn the background white. The main light is into a shoot-through umbrella and reflected off the silver side of a California Sunbounce Micro Mini reflector.

Back to film

Film is not dead. That's right, not only is film not dead, but also I highly recommend getting out that old film camera and running a roll through it! There are still working professionals who use and prefer film for their work, and why not?

With film, the processing lab handles many of the things you would usually need to do when you are sitting in front of your computer, or these would be determined by the film itself: exposure, contrast, and saturation are all largely determined by the film and its processing.

Modern labs that process film will also be able to scan your negatives as soon as they're developed, so you can get clean, high resolution scans that are ready to be printed or downloaded to your computer in anticipation of any further manipulation.

More important, film is fun! Film is creative. Film is like a holiday: waiting for your negatives and prints to be developed will take you back to a time when there was *anticipation* in photography, where you wouldn't know

the outcome—good or bad, underexposed or overexposed—until you went back to the lab. There was perhaps also a greater sense of achievement when you got everything right.

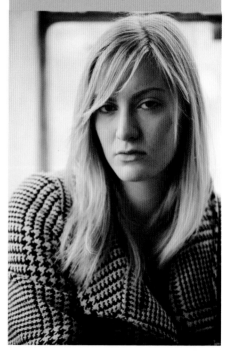

FILM STOCK
Film is uniquely adept at handling highlights and shadow detail in the final image. Here, in this film shot, developed and scanned and directly out of the camera, you can see that digital manipulation later was not necessary.

Nikon F100,
70–200mm vr lens,
Kodak Portra 160 35mm film,
SB800 into a shoot-through umbrella

Lo-fi film photography

Not only get that film camera off the shelf, but also try something new. The Holga is an inexpensive Chinese toy camera that accepts medium format 120 film. The allure of the Holga is the "bad" photos you get out of it. You need to tape the seams to prevent light leaks and change the film on the spool with care, since the camera's fit and finish is loose at best. It takes soft, barely focused photos with a built-in vignette. You have only a few settings for manual focus: 3ft (1m), 6ft (1.8m), 12ft (3.6m), and infinity. There are no exposure controls except for an approximate 1/100 sec. shutter speed and an f/9–f/10 aperture, depending on the model you get. You can produce multiple exposures by depressing the shutter-release button multiple times on the same frame with cool results. Plus, you can mount a Pocket Wizard to the hotshoe and fire your flashes!

TOY CAMERA
Coming under the heading of extreme creativity, a Holga toy camera allows you the freedom to screw it all up and yet get a fun and great result. One photo was left on the roll of landscape shots when the second exposure was taken in a studio using off camera flash.

Tip

Using a Holga with radio triggers
To use the radio triggers with a Holga, you need to do one thing. Depress the shutter-release button and let the flash fire, then turn off either the flash or radio trigger or change the channel, *then release the shutter-release button. When the shutter-release button releases from the initial exposure, it snaps open again, so you'll get an overexposed image due to the extra flash being fired.*

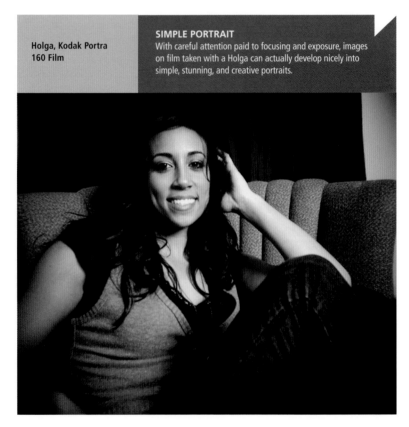

Holga, Kodak Portra 160 Film

SIMPLE PORTRAIT
With careful attention paid to focusing and exposure, images on film taken with a Holga can actually develop nicely into simple, stunning, and creative portraits.

Fun point of view

Take on a personal or fun project. In this image I was teaching a class and the final assignment at the end is to put your camera somewhere you normally wouldn't. Think of a TV commercial. The actor opens the refrigerator looking for a beverage and we, from our couches, see him from the point of view of being inside the refrigerator. Now that refrigerator is a prop with the back cut out of it, but try something creative like that. Change your camera angle or point of view. Put your camera somewhere you normally wouldn't and you'll be surprised at the result. Even though I'm the instructor, I always participate. In these images, I placed one speedlight behind my camera in my washing machine then I placed a second speedlight on the floor next to me for hair and separation lighting. It was fun to do, funny to see the final result, and creative. It has all the ingredients of a successful shot.

Nikon D3, 15mm fisheye lens, ISO 200, 1/60 sec. at f/8, Nikon SB900 inside washing machine, Nikon SB800 on laundry room floor.

SELF PORTRAIT
Prefocusing the lens to the infinity sign on the lens barrel allowed for this creative exposure to happen. Also, I used the camera's self-timer to set the exposure to happen 10 seconds after I depressed the shutter for this fun self portrait.

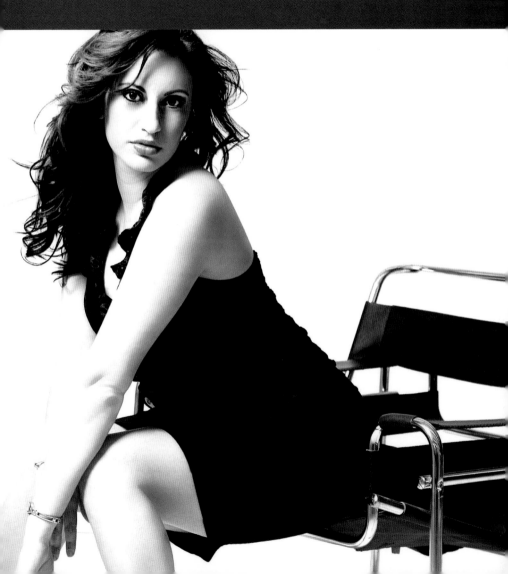

CHAPTER 7 ONE SPEEDLIGHT, 13 LOOKS

Getting creative

So you've put your flash on a lightstand and have followed along closely to the point of confidence in your off-camera flash images. Now's the time to get more creative. Here's how to achieve great, professional results with just one flash, a reflector, and that's about it.

One of the great attributes of off-camera flash is its simplicity. Once you get comfortable with how it works, the only thing that will hold you back is your creativity. Another great attribute of OCF is portability. In just one short two-hour sitting, I was able to reconfigure and move all of the gear used in this chapter around the studio and create 13 different looks with only small changes to the overall gear and how it was positioned.

The model for the following series of shots will be the same person. This will maintain continuity so you can actually see the changes in lighting without having to change people or locations. The entire shoot for this chapter was done in one afternoon in the studio. But you don't need a studio. We'll be using all the basic equipment that has been discussed in previous chapters. The setups will all be outlined and contain behind-the-scenes shots so you can duplicate what is in the book and get your own experience with minimal trial and error.

There are a few caveats:

1. Exposures may vary per camera. Each sensor is different so the exposure information I give is relative. If you find the image is too bright, adjust your shutter, aperture, ISO, or flash power.

2. Depending on the brand of flash you are using, your total flash power output may not match the examples, so again adjust your settings accordingly using shutter, aperture, ISO, and flash power.

3. I prefer long lenses for compression; my favorite lens for this type of work is a 70–200mm zoom, but any lens will do.

That should about do it. We'll be looking at using one speedlight and a reflector to get 13 different looks with one model in one afternoon. I'll give you my base exposure information here and then adjust it at each look. I'm setting my white balance to a preset selection in the camera. I know that daylight gives me the closest result to neutral. I may adjust in post processing to achieve a certain look, but for this series, all white balance settings will remain the same and all images will be processed from RAW to JPEG without any significant exposure processing: what you see is how I saw it on my LCD.

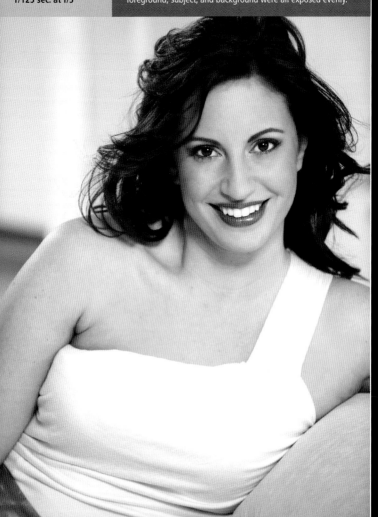

Nikon D3, 70–200mm
f/2.8 VR lens,
ISO 200, WB daylight,
1/125 sec. at f/5

TOP LIGHT
Using a single speedlight and softbox from high and above,
the light spread was full and enveloped the model so that the
foreground, subject, and background were all exposed evenly.

Camera settings:
Shutter, aperture, ISO as given for each image
White Balance: Daylight or Direct Sunlight

Flash Used:
Nissin Di866
Nissin PS 300 Portable Power Pack
Nissin settings: Manual Mode at ½ power

Lighting equipment used:
Manfrotto 1052 BAC Lightstand
Matthews 40in. Hollywood Grip Arm
Lumopro LP633 Umbrella Bracket
Photoflex 45in. convertible umbrella
Small Rogue Flashbender
California Sunbounce Micro Mini: white/silver
California Sunbounce grip head adapter
Blowit fan
Seamless white paper

Look 1: Simple bounce flash

Simple bounce flash is just that, simple!
Bounce flash is a technique used by most
wedding and event photographers to get
soft lighting on their subjects with on-
camera flash. If all you have is a lightstand
and umbrella bracket, you can still get great
results. Of all the techniques it is probably the
least expensive and easiest to execute. All we
do is put a simple bounce card light modifier,
in this case a Small Rogue Flashbender, on
the flash to help point the flash in the right
direction and bounce it off the wall or nearest
intersecting point of wall and ceiling.

Here we'll be looking at another concept
we've talked about: angle of incidence and
angle of reflectance. The angle of incidence is
where the light will hit the wall, and the angle
of reflectance is where the light will come
back to the subject. In the behind-the-scenes
(BTS) shot below, you'll be able to see how this
works. The shadow detail on the model has
a bit of strong contrast. This type of bounce
light is a trial and error lighting situation. Light
bounced off of a hard white wall will show
differently than if that same light is bounced
off of a darker wall or a wall further away from
your subject.

Nikon D3, 70–200mm
f/2.8 VR lens,
WB Daylight, ISO 500,
1/125 sec. at f/5.6

RADIO POPPER PX
Flash Equipment: Nissin Di 866, Nissin NDP 300 N Battery
Pack, Pocket Wizard Plus III, flash in Manual Mode at ½
power, small Rogue Flashbender

Look 2: Reflective umbrella

Master the basics of one light and you'll be able to master your second and third in no time. The traditional reflective umbrella shot is a great way to practice; this is the basic 45° x 45° portrait lighting shot. Even though reflective umbrellas throw and scatter light all over the place, you can get a feel for how the light interacts with your subject. Reflected umbrella light is cool and contrasty and yields a simple yet wonderful portrait. Notice how the shadow detail across the model's face is soft, yet still maintains that air of contrast that is indicative of reflected light. The umbrella is one of the simplest, least expensive, and pleasing kinds of light. Plus, you can move your subject around or you can move to one side or the other of the light and change the overall look and tone of your image.

FLASH EQUIPMENT:
Flash Equipment: Nissin Di 866, Nissin NDP 300 N Battery Pack, Pocket Wizard Plus III, flash is in Manual Mode at ½ power, Photoflex reflective umbrella

Nikon D3, 70–200mm f/2.8 VR lens, WB Daylight, ISO 200, 1/125 sec. at f/5.6

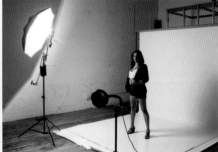

Look 3: Reflective umbrella and reflector

In this setup, the addition of the reflector will "fill" the opposite side of the model. The reflected light will open up the shadows on the opposite side of the main light and give us more detail on the darker side of her face. You can adjust the amount of fill by using the Inverse Square Law *(see page 38)*. If the main light is set, then you can get more or less fill light with the reflector by moving it closer or farther from the subject, much the same way and same effect is achieved when you move the light in or out.

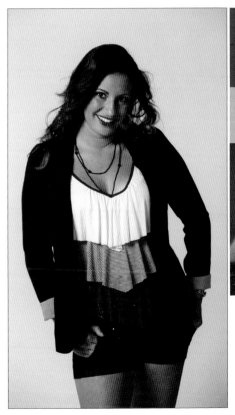

FLASH EQUIPMENT:
Nissin Di 866, Nissin NDP 300 N Battery Pack, Pocket Wizard Plus III, flash is in Manual Mode at ½ power, Photoflex 45in. reflective umbrella, California Sunbounce Micro Mini with grip head

Nikon D3, 70–200mm f/2.8 VR lens, WB Daylight, ISO 200, 1/125 sec. at f/5.6

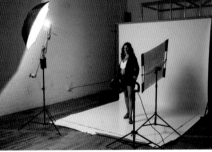

Look 4: Side light, reflective umbrella

By just moving the umbrella to one side of the model and not worrying about any shadows, highlights, or catchlights, we are able to get a subtle split light effect on the model. I've not changed any settings on the light, all I've done is move the light to one side and kept it at approximately the same distance from her as when it was in the 45° x 45° portrait setup. This is a great time to pay attention to your histogram. You'll notice that it will favor the blacks, or left side, as we are putting our subject into severe shadow, but this is the effect we are after: that split light dramatic portrait. But don't let the histogram fool you here since the exposure on the model's face is good: it is the dark shadows that are pushing the histogram to the left.

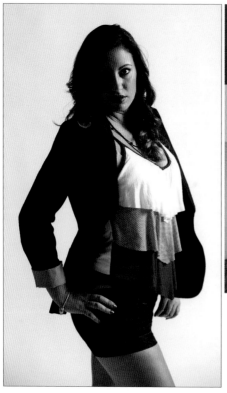

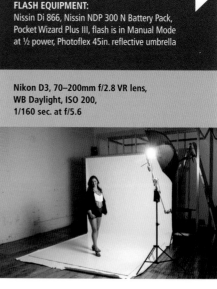

FLASH EQUIPMENT:
Nissin Di 866, Nissin NDP 300 N Battery Pack, Pocket Wizard Plus III, flash is in Manual Mode at ½ power, Photoflex 45in. reflective umbrella

Nikon D3, 70–200mm f/2.8 VR lens, WB Daylight, ISO 200, 1/160 sec. at f/5.6

Look 5: Collapsed reflective umbrella

For this look, the umbrella returns to the 45° x 45° typical portrait setup, but the umbrella is now collapsed and sits in that configuration. This type of shot will produce deep shadows on the model, with a great deal of dramatic falloff on the side of the model's face. In this form, the light takes the shape and style of the soft light reflector or what is commonly known as a beauty dish. Professional dishes can cost hundreds of dollars, but by using this technique we can avoid that expense. Just by closing the umbrella down but leaving it in the traditional portrait setting, we are able to again completely change the look of the photograph but still use the same lightweight and versatile modifier: the convertible umbrella.

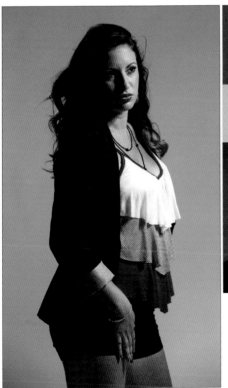

FLASH EQUIPMENT:
Nissin Di 866, Nissin NDP 300 N Battery Pack, Pocket Wizard Plus III, flash is in Manual Mode at ½ power, Photoflex 45in. reflective umbrella, collapsed

Nikon D3, 70–200mm f/2.8 VR lens, WB Daylight, ISO 200, 1/160 sec. at f/5.6

Look 6: Shoot-through umbrella

Once you've mastered the one-light reflective umbrella, take the black backing off and use it as a shoot-through umbrella instead.

The shoot-through umbrella is the favorite way for many photographers to use an umbrella, as the light is not scattered as much as it is with a reflective umbrella, and it can be directed to control not only spill light, but also how much light is hitting the model's face. Being able to control the light like this is crucial. While there are times when the reflective umbrella is the best solution, more often than not you'll begin to gravitate toward the shoot-through to get more control.

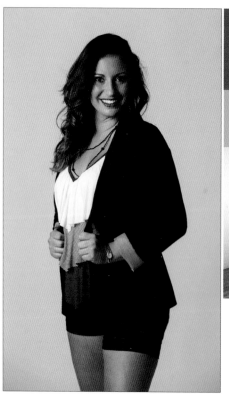

FLASH EQUIPMENT:
Nissin Di 866, Nissin NDP 300 N Battery Pack, Pocket Wizard Plus III, flash is in Manual Mode at ½ power, Photoflex 45in. shoot-through umbrella

Nikon D3, 70–200mm f/2.8 VR lens, WB Daylight, ISO 200, 1/125 sec. at f/5.6

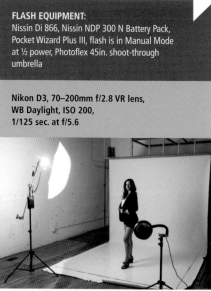

Look 7: Shoot-through umbrella and reflector

Having the control that's offered by a shoot-through umbrella is fabulous, especially when you couple it with a reflector.

In this straightforward single light setup a white reflector has been angled at 45 degrees to the flash. The result is that the model is "sandwiched" with light, bringing beautiful soft light to both sides of your model's face, but without any harsh shadows. By directing the light toward the reflector, we gain warmth in tone and a softness of light that is equal to—or in some cases better than— the most expensive strobe light and softbox combination. Further control can come through the use of a different colored reflector: gold to warm the skintone, or silver for a harder fill.

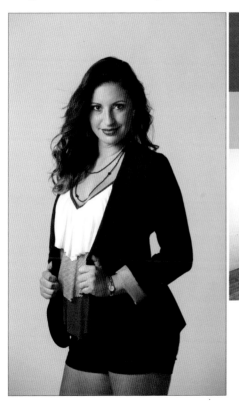

FLASH EQUIPMENT:
Nissin Di 866, Nissin NDP 300 N Battery Pack, Pocket Wizard Plus III, flash is in Manual Mode at ½ power, Photoflex 45in. shoot-through umbrella, California Sunbounce Micro Mini with grip head

Nikon D3, 70–200mm f/2.8 VR lens, WB Daylight, ISO 200, 1/125 sec. at f/5.6

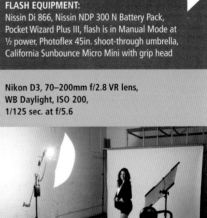

Look 8: Creative shoot-through umbrella

By just moving the shoot-through umbrella to one side of the model and not worrying about any shadows, highlights, or catchlights, we are able to get a subtle split light effect on the model. As with the previous setup (with the reflective umbrella), I've not changed any settings on the light—all I've done is move the light to one side, keeping it at approximately the same distance from her as it was in the 45° x 45° portrait setup.

Now is the time you may have to change your exposure as you are only exposing on one complete side and not anywhere in the front. Also, pay attention to your histogram. You'll notice that it will favor the blacks or left side since we are putting our subject into severe shadow, but this is the effect we are after: that split light dramatic portrait.

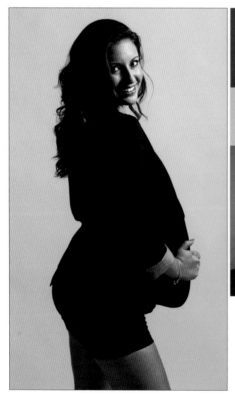

FLASH EQUIPMENT:
Nissin Di 866, Nissin NDP 300 N Battery Pack, Pocket Wizard Plus III, flash is in Manual Mode at ½ power, Photoflex 45in. shoot-through umbrella.

Nikon D3, 70–200mm f/2.8 VR lens, WB Daylight, ISO 200, 1/125 sec. at f/8

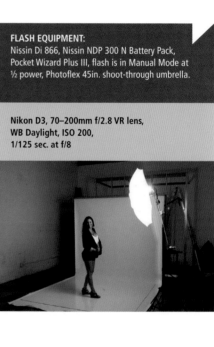

Look 9: Direct light

This is magazine-cover quality light and it's easy to execute. The lighting is direct and overhead and is one of the advantages of using the Matthews Hollywood Grip Arm and having the ability to get your light up and out of the way. This lighting setup removes the 45° x 45° shadows we've become accustomed to and gives us a nice flat light with soft shadows under the nose and chin and a beautiful soft drop shadow on the wall behind the model. For this technique, move your subject as close as you can to the backdrop in order to achieve the drop shadow. Look at any magazine cover these days, and you'll see the effect. It's pleasingly soft and very simple.

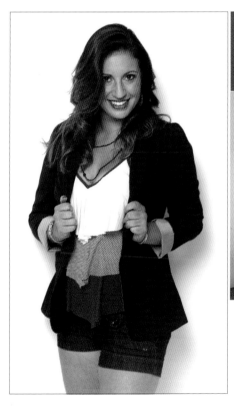

FLASH EQUIPMENT:
Nissin Di 866, Nissin NDP 300 N Battery Pack, Pocket Wizard Plus III, flash is in Manual Mode at ½ power, Photoflex 45in. shoot-through umbrella

Nikon D3, 70–200mm f/2.8 VR lens, WB Daylight, ISO 200, 1/125 sec. at f/5.6

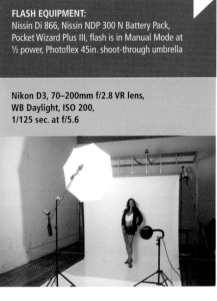

Look 10: Over and under beauty light

This quality of light is a favorite of headshot and beauty photographers, and we are going to accomplish it with just one speedlight and reflector. This particular kind of shot is easy to set up and execute and it gives the most complimentary light for beauty portraits. This shot is exactly the same setup as in Look 6 (see page 158), except that the light is directly overhead and the reflector is directly beneath the model's face; all we need to do is move the equipment around and take our test shot to set exposure. Again, we light around our subject. The speedlight is pointing directly down and toward the reflector for simple, elegant, soft, main and fill light in a small area. Look in any fashion or glamour magazine at the catchlights of any beauty advertisement and you'll see some variation of this simple setup.

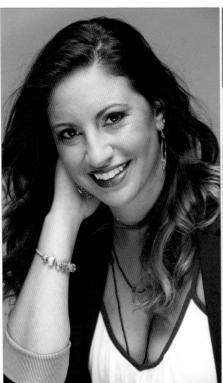

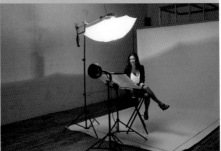

FLASH EQUIPMENT:
Nissin Di 866, Nissin NDP 300 N Battery Pack, Pocket Wizard Plus III, flash is in Manual Mode at ½ power, Photoflex 45in. shoot-through umbrella, California Sunbounce Micro Mini with grip head

Nikon D3, 70–200mm f/2.8 VR lens, WB Daylight, ISO 200, 1/125 sec. at f/8

Look 11: Bounce light into a reflector

Bouncing light into a reflector is a great way of getting a lot of light onto your subject. This is helpful when you have to shoot a small group and don't have the gear to do the job. You can light several people in a group inside or out and get beautiful soft yet contrasty light. I've done this before with on-camera flash at events. I'd have my assistant hold the reflector close to me and I'd bounce my light just as if I was in an event space. But here, I'm using two lightstands: one for the reflector and one for the flash. Just point the flash toward the reflector and shoot. The quality of light equals that of the much more expensive parabolic reflectors on the market and widely used beauty lighting.

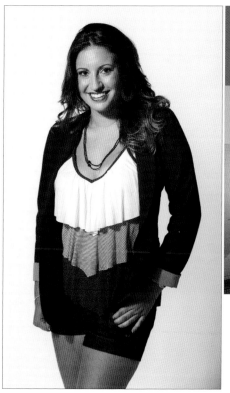

FLASH EQUIPMENT:
Nissin Di 866, Nissin NDP 300 N Battery Pack, Pocket Wizard Plus III, flash is in Manual Mode at ½ power, bare head flash, California Sunbounce Micro Mini with grip head

Nikon D3, 70–200mm f/2.8 VR lens, WB Daylight, ISO 200, 1/125 sec. at f/8

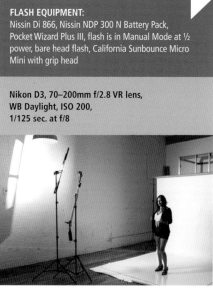

Look 12: One light into two

This setup is more advanced and difficult to execute. We are using the speedlight to mimic the sun. One of the basic tools a photographer should own is a great reflector. When shooting outside, the reflector can be a main or fill light since we can bounce sunlight into it and light our subject efficiently. Here, we are doing the same thing in the studio: the speedlight is our sun. By positioning the speedlight behind the model and pointing it toward the reflector,

we've essentially created our reflected light portrait. We'll get a hair light and a main light, just as we would shooting outside and using the sun. This technique takes practice since the light position in relation to the subject and reflector needs to be accurate or you'll get lens flare as the light enters the front of your camera and doesn't hit the reflector properly. But give it a try and you'll be surprised at the simplicity of the setup and the great results you can achieve.

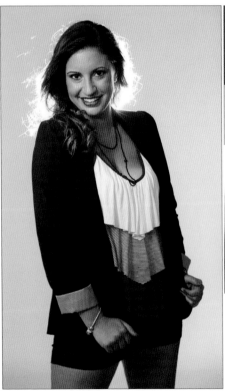

FLASH EQUIPMENT:
Nissin Di 866, Nissin NDP 300 N Battery Pack, Pocket Wizard Plus III, flash is in Manual Mode at ½ power, bare head flash, California Sunbounce Micro Mini with grip head

Nikon D3, 70–200mm f/2.8 VR lens, WB Daylight, ISO 250, 1/125 sec. at f/4

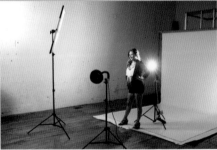

Look 13: One light, high key

This is one of my favorite setups as it only takes a white background and one bare head speedlight. This look and technique is also popular with fashion and magazine cover shots. After you've done this shot, take a look at any magazine rack and you'll find this technique being used. Simply move your subject close to the white background and shoot. You'll achieve that short drop shadow on a bright white surface in one shot! You can control the drop shadow and move it to one side or the other of your subject by moving your light to the right or left of your camera based on your taste (or what your client wants). Then, move your subject away from the white backdrop about 3ft (1m) to make the drop shadow more pronounced. You can also raise or lower your light to get a taller or shorter shadow. This is a fun technique that requires very little to execute.

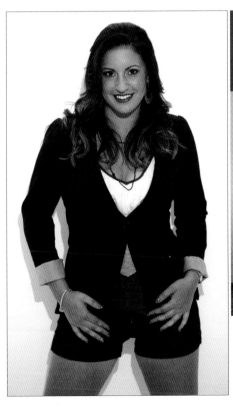

FLASH EQUIPMENT:
Nissin Di 866, Nissin NDP 300 N Battery Pack, Pocket Wizard Plus III, flash is in Manual Mode at ½ power

Nikon D3, 70–200mm f/2.8 VR lens, WB Daylight, ISO 400, 1/125 sec. at f/5

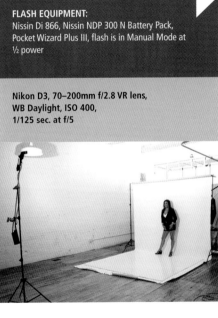

CHAPTER 8 POSTPROCESSING

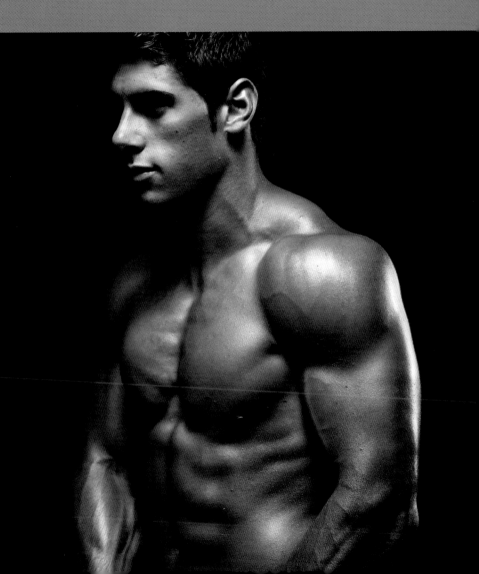

Plan and refine

Digital photography enables us to completely manipulate our images in ways that could never before even be dreamed. Computer processing programs give us the options to change images in such ways that even the worst can now be called art. The print darkroom is now called the digital darkroom, and the computer is an essential part of the digital photographer's workflow.

Initial image correction

We see and create images not for printing, but for planned processing after the initial capture. We shoot in RAW format, which ties us to our computers for extended periods of time. We use RAW conversion software to process JPEGs, move those initially edited images to programs such as Adobe Photoshop, and then we save and print or go further and process the images using actions, or third party plugins, or we even make our own recipes for image manipulation. Whatever the initial reason for capturing the image to its final output, we spend hours of time in the digital darkroom.

Processing for flash photography is not that different to processing our regular family, travel, and fun photographs. Once we get to know our equipment and how flash affects our images, the process becomes less daunting. Shooting in RAW format as opposed to JPEG allows more control over the final product, as important factors such as exposure and white balance can be corrected on the RAW file and

a new JPEG made. If you don't like the edit, delete the JPEG image and start anew.

We begin our journey into post processing after we've downloaded our images into our software. If shooting in RAW, we have a host of choices for conversion software to fit our needs, starting with the proprietary offerings from Canon, Nikon, Olympus, Pentax, Sigma, and Sony give a good variety in choosing the program that works the best for us.

Beyond the camera manufacturer's software are options such as Adobe Camera Raw, Adobe Lightroom, Aperture, Bibble, Capture One, and DXO, which are the most popular on the market.

All of these programs offer us the initial adjustments to get our photos converted to one format such as TIFF or JPEG for final print output. Exposure panels allow us to completely change the look of our RAW images without damaging the original image; thereby allowing us ultimate control over the final product.

Looking at the histogram may tell us that the original image is a little underexposed, for example, or we may want to change the white balance, contrast, and saturation. While the image doesn't look too bad in software, it needs a touch of help, and shooting RAW enables us to give it just that, without degrading the quality of the image.

**ISO 400, WB Daylight,
1/30 sec. at f/4,
Nikon SB910, Manual Mode, ½ power**

THE DIGITAL DARKROOM
One of the first edits is exposure. Sometimes the LCD on the back of the camera tells a lie. Camera companies make these screens bright and in high definition, so when you view the image it may look perfect until you get back to your computer and find it's different. Computer editing software allows some leeway in your final image. It's important to try and get it right in camera, but later, once on your computer, you can make exposure one of your first adjustments.

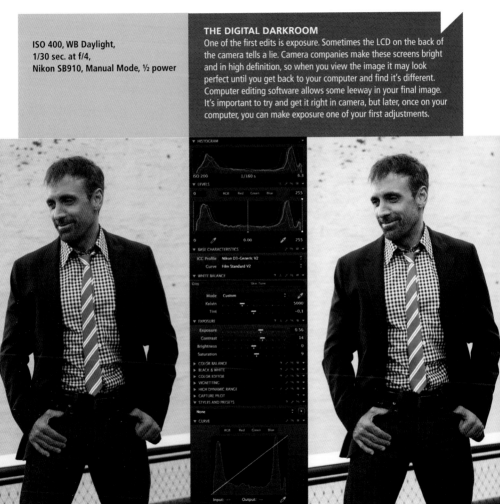

White balance

Getting correct color is crucial to your success as a digital photographer, but not always. What if you want that warm or cool look to your photo? What if you are looking to create a mood and change the white balance from 5500K down to 3200K? Like all things in photography your artistic choice rules the day and it is up to you to decide what color temperature and tone suit your final image choice.

White balance is one of the main reasons photographers shoot in RAW format. Having the ability to process multiple copies of one image at different exposure and color temperature setting allows us to take advantage of the software and digital file while in the digital darkroom.

Getting correct white balance at capture does help to speed up the post process, that time when we are glued to our computer screens and are trying to decide on the look we want for our images before they go out to a client or to print for ourselves. Before you even start shooting

Tip

White balance is a creative choice you as the photographer need to make. Do you want color tone to be technically correct, slightly warm, or slightly cool? It is up to you, the art director (if there is one), and ultimately the client to choose the final product. Shooting in RAW format allows photographers to change white balance creatively without harming the image, as the image isn't totally processed yet.

you should consider your white balance choices: taking a custom white balance with an Expodisc *(see page 23)* is one solution. By using a neutral gray target aimed at the main light source, you can measure your color temperature at capture and lessen your time in postprocessing.

But now we are beyond initial capture and we are at the computer trying to decide what

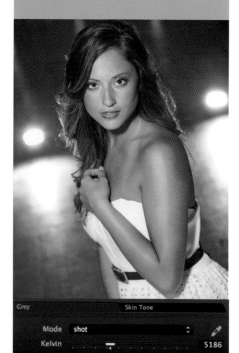

NEUTRAL TONE
This image shows the Neutral Tone Expodisc. Compare the effect with the three images on page 22, which used a Warn Tone Expodisc.

is going to work best for us. In the shot shown below, there are three choices: (L–R) as shot, completely correct, and something in between. The choice is not an easy one to make. Will the client like the one that's cool, medium, or warm? Or is it up to the photographer to deliver what he thinks is correct? The issue now becomes not choosing the "correct" white balance, but choosing the temperature that works for the image itself and the look trying to be conveyed.

In this instance, the image at 4500K (below right) was chosen as the one to be delivered to the client. That temperature fell in between the captured image and the completely corrected image. Changing to a middle temperature in between "correct" and "as shot' was an artistic choice that allowed a bit of warmth to remain in the image, the whites to go nearly white, and skin tone to remain warm (but not too warm).

These are choices that we as digital photographers are confronted with every day that seem to be sometimes overwhelming and counterproductive. We need to balance our WB with our artistic vision.

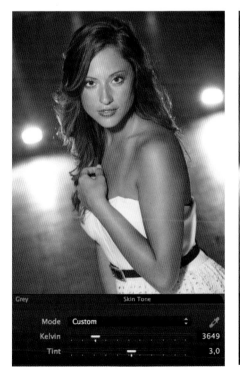
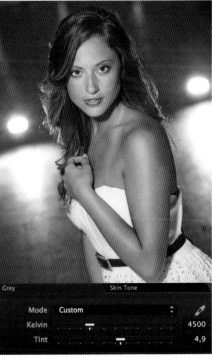

Adjusting exposure

Usually by the time we get into the digital darkroom most of our adjustments have been done and we are fine-tuning the image to our liking: removing blemishes, softening skin, one last exposure and color check just in case the image just doesn't feel right before delivery. Some features of plugin programs, such as like Nik Color Effex Pro, darken the image a touch when a particular adjustment is applied, so exposure and color and everything you think about changing in an image is infinitely adjustable in Photoshop.

The histogram tells us all about the blacks to the left and the whites to the right. The histogram in this photo favors the left, since the model was photographed in a low-key setting against a black backdrop. By using the Levels Layer, we not only see the exposure values but also can adjust for them by dragging the white slider to the left. This opens the photo up and brightens the entire image. Even though the blacks are brightened, they are not overexposed; and even though her skin is now brighter and more evenly exposed, it is not blown out or suffering from any loss of detail. The low-key look is a unique and specific look that accentuates tone and detail, so we strive to maintain that in the image without destroying it. It is important to get as much right as possible at capture, but when you can't, you can rely on the Levels command to make slight adjustments one way or the other.

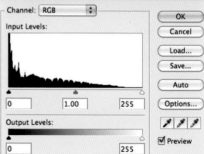

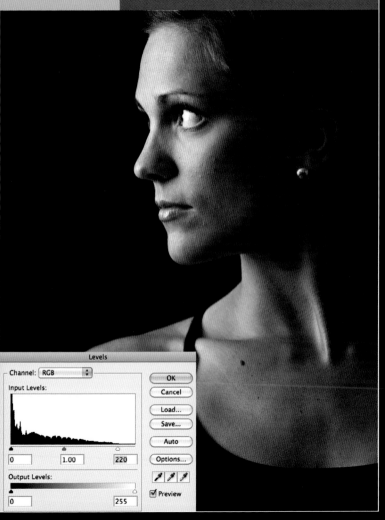

Nikon D3, 70–200mm lens,
ISO 200,
1/250 sec. at f/6.3

ADJUSTED HISTOGRAM

In the adjusted histogram, the whites read 220. The white slider was drawn to the left to open up or bring the exposure up on the brighter side of the histogram. This allowed me to lighten the overall exposure with one simple adjustment.

Levels

Channel: RGB

Input Levels:

OK
Cancel
Load...
Save...
Auto
Options...

0 1.00 220

Output Levels:

☑ Preview

0 255

Shadows, highlights, and recovery

When we shoot we must pay attention to highlight clipping or the "blinkies." The blinkies tell us when we are losing detail in our images. If you haven't already, turn the highlight clipping

> **BLINKIES**
> In the original image you can see the highlight clipping on the screenshot. Highlight clipping, or the blinkies, represent lost detail. If they are minor, then detail can be brought back in software using the recovery or highlight sliders depending on your software. It is important to note that you want as few clipped highlights as possible, especially on faces and skin.

warning on in your camera. While it's important to pay attention to highlight clipping, especially on people's faces, it is sometimes hard to avoid, or your software may pick up clipping in the RAW file where your camera did not. To combat the blinkies, pay strict attention not only to the clipping warning but also to the histogram.

In this image the histogram (below left) is nearly perfect, but the fact remains that the light hitting the model's face on the high spots is just a bit too much, so there is a touch of highlight clipping.

Adobe Camera RAW allows you to recover clipped highlights and create a "fill light." Here, the recovery slider was drawn to the right until it cleaned up the highlights and I added some fill light to recover the black in the shadows. Although the shadows are not seen, recovering some of the blacks helped to make the image brighter without pushing the exposure too far to the right. These sliders help to facilitate RAW image adjustment and allow images that might otherwise be deleted to be saved and sent out to a client for proofing and print. This is the power of shooting in RAW format: ultimate image control.

The final image hasn't even gone through any editing or cleaning in Photoshop; it has only been adjusted in its RAW state and then it will be saved as either a DNG or TIFF for final image manipulation and before it is finally converted to a JPEG for the internet or print and delivery to the client.

BEAUTY LIGHT

This image was shot using a technique called over and
under beauty light. Using a shoot-through umbrella and
a silver reflector underneath, this type of lighting is soft
and pleasing on anyone's skin. Notice the catchlights in
the model's eyes: you can see the light above and the
reflector below.

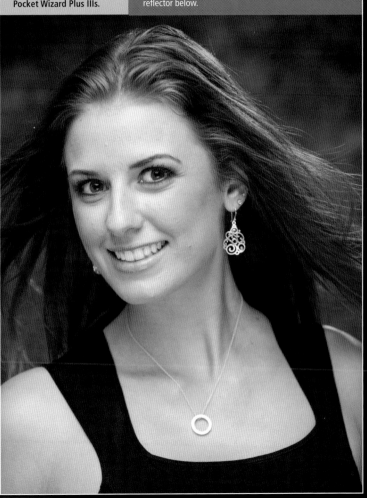

Sharpening

Every RAW file needs some kind of sharpening before final output. Even the best RAW converting software leaves a bit of softness in the image that needs attending. There are a few different ways to sharpen in Photoshop.

Unsharp Mask

For print output, use the basic Unsharp Mask to sharpen an image to taste and get the most out of your capture. The best and most convenient aspect of Photoshop is Smart Filters and Layers. This seaglass in the image below was placed on a white plexiglass sheet and lit with a speedlight from underneath. Using the Unsharp Mask technique, the edges of the soft seaglass are now more defined and the image will print with good edge detail.

To get to the Unsharp Mask feature go to **Filter>Sharpen>Unsharp Mask.** The following settings can be applied once, or maybe even twice or more, depending on the sharpening effect required: Amount 85, Radius 1.0, Threshold 4.

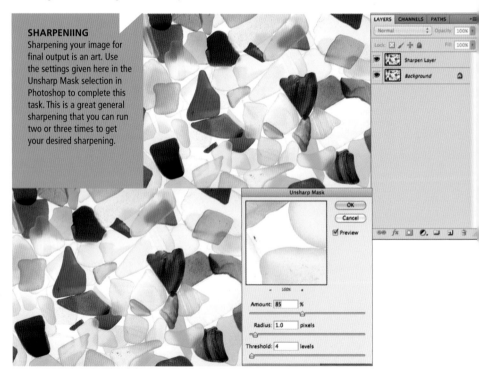

SHARPENIING
Sharpening your image for final output is an art. Use the settings given here in the Unsharp Mask selection in Photoshop to complete this task. This is a great general sharpening that you can run two or three times to get your desired sharpening.

Removing red-eye

Red-eye is a by-product of direct flash, as the light bounces off the retina in the eyes of the subject. It's an annoying element of any photo and almost all new cameras have a red-eye reduction setting that uses multiple pre-flashes to prepare the eye for the last and final flash in which the photo is taken. However, sometimes the setting is not turned on, or the angle of the flash to the subject is such that the retina isn't fully prepared for the last blast of flash.

Red-eye can be handled through an action in most software applications and is an easy fix; however, if you find you have a difficult situation, then Photoshop is your next stop. There are a great many ways to remove red-eye, but in the extreme example shown below,

which is the direct result of using a ring light, we are going take a few steps to correct this image, as shown overleaf. These steps will also allow you to remove color casts from images as well. This image also suffers from a slight red color cast that sometimes is a by-product of the infrared light of flash coloring and giving a red color tone to an image.

By selecting the Hue/Saturation layer and working on one layer at a time, the red in the image was decreased by a value of -20. At this point, the skin tone of the model has been improved greatly. Usually if you need to remove the reds from skin that has been flashed directly, you'll be in the -10 to -20 range in the red slider on the Hue/Saturation layer. This is where things get a bit more complicated. Because the red-eye

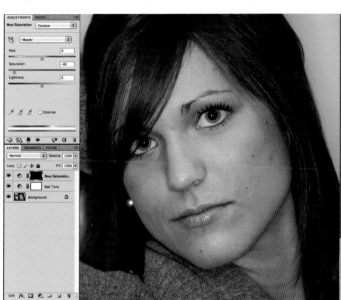

REMOVING RED-EYE
Red-eye is the bane of the flash photographer. This image, taken with an Orbis Ring Light and Nikon SB900, shows how the model's eyes react to the bright flat light. When using direct flash, use the red-eye reduction setting in your camera's flash menu. The series of preflashes prepares the iris for the immediate blast of light and you can avoid red-eye altogether.

Nikon D3, 70–200mm f/2.8 VR Lens, ISO 200, 1/60 sec. at f/4.

encompasses the model's entire pupil, we have a lot of red to remove to even begin to make it look presentable. On top of the last Hue/Saturation layer add another Hue/Saturation layer. Then, drop the reds out again; in this case, by eye, I went down to -82. Now the model's eyes look much better, even though the pupils are dilated. Now take the white layer mask and drag it to the trash. Once this is done, depress the alt key and click on the new layer icon on the bottom of the layer palette. A black layer will appear and your image will turn back to the original with all the red-eye there. Select the paintbrush tool, make sure you select white to paint out the black layer, and make the brush the size of her pupil. Then simply click on the pupil and the underlying corrected layer without any red will show through. This is not only an exercise to rid a photo of red-eye, but also an exercise to remove red tone that can happen in digital capture and explore the black masking technique. Here's the final result, below:

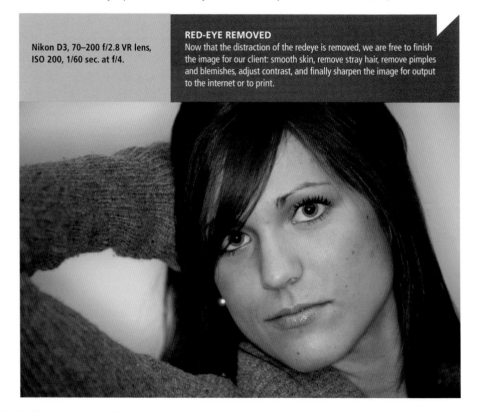

Nikon D3, 70–200 f/2.8 VR lens, ISO 200, 1/60 sec. at f/4.

RED-EYE REMOVED
Now that the distraction of the redeye is removed, we are free to finish the image for our client: smooth skin, remove stray hair, remove pimples and blemishes, adjust contrast, and finally sharpen the image for output to the internet or to print.

Simple black and white

Black and white images evoke emotions of the past, of classic portraiture, and seminal events in our history. It's no wonder that people love black and white images. Again, there are many ways to convert your images to black and white, and a great many different products on the market that offer you preset black and white looks, which can also add grain to make them look old. The simplest way to a black and white image is to simply desaturate it in the Hue/Saturation layer. Once in Photoshop, create a Hue/Saturation adjustment layer and desaturate all of the color from the image. Once this is done you have a simple black and white image.

The problem with this conversion is that the desaturation causes the image to lack contrast. Without significant contrast, the image is flat and uninteresting. To bring that contrast between the light grays and the deep blacks of the model's dress in the image below, create a Brightness/Contrast layer and set the contrast to taste. Here it has been increased by 100% so that the image now is full of contrast and will print beautifully.

Nikon D3, 70–200mm f/2.8 VR lens, ISO 400, 1/250 sec. at f/4.5.

LENS CHOICE
Using a longer focal length lens, like a 70–200mm or 70–300mm will give you compression. The lens compresses the background to give you that soft out of focus area and help to separate your subject from the foreground. Longer lenses also allow you distance from your subject so they are not intimidated by you getting too close.

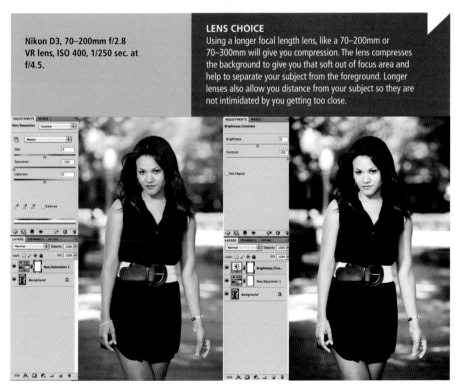

Two-click color correction

One of the techniques you need to learn is not only how to shoot for white backdrops but also how to correct for them when they don't turn out perfectly white. Ideally, there is enough room in your studio to light the background separately, but if not, or if something goes wrong, there's a simple solution in Photoshop: Levels.

Light is not the only element that can affect whether or not the white backdrop you worked so hard to light appears pure white in your final shot. Your lens may also have an affect on the white backdrop, especially in the corners where vignetting may occur. Vignetting is a side effect of lens design and, while not every lens has or is plagued by this occurrence, it can lead to darkening toward the corners. However, annoying as it can be, vignetting is easily fixed during postproduction.

In the Levels palette are black, gray, and white droppers used to sample those colors in the image for color correction and to add contrast or fix color issues. Click on the white dropper and then click on the darkened corner (or a darkened spot) on what should be your white background or foreground. Watch as the image is corrected not only for the whites, but also for color and contrast too.

Next, click on the black dropper and find the darkest spot on the image and click there to adjust for the deep colors in the image. Watch how two-click color correction changes the look and feel of the image.

Despite all the benefits of RAW files, they still sometimes lack contrast and are in need of some help. With the two-click color correction technique you can adjust your image to make it look better than real life, and if it doesn't, you can simply try a different adjustment.

1

DIRECT FRONT FLAT LIGHT

This type of lighting provides short drop shadows under the nose, chin, clothing, and on the background. It is an easy one light setup that is a favorite of fashion and magazine covers as it is fast and simple to execute.

Nikon D3, 70–200mm f/2.8 VR Lens, ISO 200, 1/125 sec. at f/5.6, Nikon SB910, Large Rogue Flashbender with diffusion panel

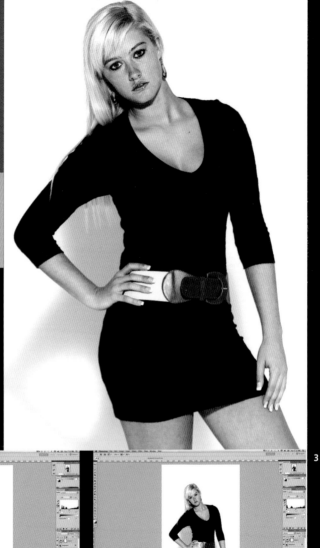

Skin retouching and softening

Retouching is an art, and professional retouchers are artists in the digital medium. Removing blemishes, pimples, warts, facial pock marks, stray hairs, and every other problem associated with digital manipulation, is the realm of the retoucher. But not all of us can afford to send our work out to the big guys, so we dabble in Photoshop and try our best to blend and clone and patch and smooth skin so we, or our clients, are happy and we don't spend our lives on our computers.

While overall retouching is not new, the digital darkroom is, and digital photography is partly to blame for all the time we spend on our computers. During the days of film, you, as the model, made sure all your hair was in one place, your makeup was applied perfectly,

Nikon D3, 70–200mm f/2.8 VR lens, ISO 200, 1/125 sec. at f/6.3, Nikon SB910 in Manual Mode, ½ power, shoot-through umbrella camera left, reflector camera right.

SKIN SMOOTHING STEP BY STEP
The effect of this skin smoothing technique is subtle and is supposed to be this way so it looks completely natural in the finished image.

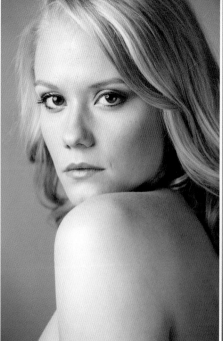
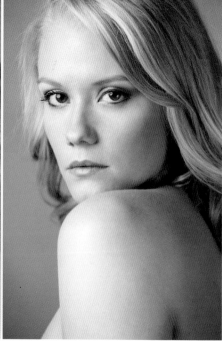

and you sat in the poses the photographer asked because part of his/her art is in posing you since he/she only had a certain amount of frames to take before your sitting was over. Now, we shoot and shoot and shoot and if we aren't satisfied we shoot some more until we think we get the shot we should have got 100 frames earlier.

Conversely, clients feel almost entitled to endless retouching, and more than once I've heard the words "Oh, you can fix it in Photoshop!" and shuddered at the thought of how long the job may take. We need to move away from this mentality, but until we do, the digital darkroom is our playground and we need simple tools to survive.

In this tutorial, we'll correct for color, contrast, skin imperfections, and do a simple yet very effective skin soften that can be adjusted using the opacity of the layer you are on. The technique is fast an effective, which should allow us more time to shoot.

Recipe:
- Duplicate background (image) layer.
- Clone stamp all blemishes.

- Healing brush and spot healing brush to remove all pimples and blemishes.

- Use Patch tool to remove bags under eyes.
- Make new layer.

- **Filter>Other>High Pass** set to 10.

• Blending mode: Soft Light.

• Go to **Image>Adjustments>Invert** to show the reverse effect of the high pass sharpening, which is a softening of the image.

• Add black mask: Hold down the Alt key and click the New Mask icon on bottom of layers palette.

• Paint the effect back in only on the skin.
• Choose the paintbrush and white as the foreground color. Paint back in softness on skin only, changing brush size for areas around the eyes, mouth, and so on.

• Flatten image and save when done.

Tip

Make a duplicate or copy of your image. Keep the original in one folder and then put the copy in another folder for processing. This way you always have an original, untouched image to go back to.

Plugins and Actions for Photoshop

There are a great many plugins and action sets available for image processing. A plugin is a separate item of software that "plugs in" to the main editing program (some also operate as a standalone program) and can be accessed through the editing program's menus.

Applications from Nik, OnOne, and Alien Skin, are a few of the very popular plugin sets, since they include effects that can cross-process images: taking daylight white-balanced images and processing them as a film lab would have with a different workflow for creative effect, simple to complex black and white conversions, darkening, adding borders, adding textures, and film effects for different film looks. Plugins integrate with Photoshop and allow creative effects to be done on separate layers so the effect can be masked or adjusted on the layer.

Actions work much the same way as plugins, but the action is preset for you and runs through the Actions palette. You can stack them one atop another to increase your effects, drop the opacity to lessen each effect on the image, and you can use layer masks to paint the effect out or back in depending on your need.

Actions such as Kubota and Totally Rad offer the photographer a wide selection of effects that can also be run through the batch editor. This means you can choose an action you like, put 20 files in a folder on your desktop, and run the batch editor or the scripts editor and Photoshop will convert all the images for you and even make new ones.

Nikon D3, 50mm 1.8 lens, ISO 200, 1/160 sec. at f/5, Nikon SB900, Westcott 28 Apollo Softbox

PERIOD PROCESSING
Try making your images into period style photos. In this image I added film grain and then swapped it to black and white with fairly low contrast to match photos of flappers from the 1920s.

Glossary

Ambient light Available or existing light in a scene.

Angle of incidence The area or angle in which light hits a subject.

Angle of reflectance The area or angle in which light reflects off of a subject.

Angle of view (field of view) The measurement of how much a lens can see in its view. A 14mm lens sees more of the world than a 200mm lens, usually measured across the diagonal of the sensor/film plane.

Aperture The opening in the lens that lets in a specified amount of light, usually denoted by the term f/stop. Sizes of f/stops are calculated by a mathematical formula taking into account specific lens information and distances to the sensor/film plane.

Aperture priority Exposure is set by choosing an aperture and letting the camera choose the shutter speed.

Artifact Something unwanted in the digital file, usually a fault of the image sensor's ability to record the requisite data.

Auto Focus (AF) System that allows a camera to focus for you, eliminating the slow nature and inconsistency of manual focus.

Auto White Balance (AWB) A systematic camera approach to reading the color temperature of the scene in front of the lens. The AWB feature attempts to give an average reading of the scene.

Backlight When your light source is facing into the camera from behind the subject.

Balanced Fill Flash Mode (BL) Atypical of Nikon flash, BL or Balanced Fill Flash allows the camera to tell the flash exact output for a certain scene when using direct flash.

Barrel distortion A defect in the lens design that causes straight lines to be curved from the center out.

Bokeh The out of focus area in an image behind, in front of, or around the subject.

Bounce flash An indirect lighting technique well suited to on-camera flash where the flash head is swiveled and light is bounced off nearby surfaces to give a softer overall lighting effect.

Built-in flash A flash permanently installed onto a camera body: either the small flash of a compact or point-and-shoot camera or the popup flash of the mid-level camera or many DSLRs.

Built-in light meter The meter built into the camera that measures light to give a correct exposure for what the camera sees in the scene.

Bulb (B) The Bulb setting allows for unlimited time exposures lasting seconds, minutes, hours, or for the life of the camera battery.

Charged Coupled Device (CCD) Similar in function to a CMOS sensor, the CCD applies an electrical charge to the sensor directly prior to image capture and is one of the most common sensors in modern cameras.

Color cast An incorrect color hue in an image, most often caused by bounce flash, which can pick up the color of the walls it is bounced off. It is easily corrected in postprocessing.

Compression Reduction of file sizes by removing information from the shadows where it is not seen in the final image.

Contrast The difference in at least two or more colors or gray tones in terms of luminance, density, and brightness.

Cookie Another word for Gobo, or Go Between, it is something placed in between the light source and subject to create an effect on the final image.

Creative Lighting System (CLS) Developed by Nikon, a system of infrared signals between the master flash and slave flash that allows off-camera use of flashes, which integrates the TTL systems for in-camera menu control of flashes.

Depth of field (DOF) Directly controlled by the aperture's size, it refers to the amount and what

is sharp in an image. Smaller apertures (eg f/22) offer more sharpness in an image than wider apertures (eg f/2.8), which let more light in and are usually softer in the immediate foreground and background.

Diopter An accessory lens that installs in front of the lens that optically tricks the lens into thinking it can focus closer than normally possible.

Direct flash Using the flash with no modifiers, like a plastic diffuser, umbrella, or softbox, for direct hard light.

Dynamic range The ability of the camera's sensor to capture a full range of highlights and shadows in an image.

Exposure The amount of light needed to properly expose the digital sensor or film using shutter speed, aperture, and ISO.

Exposure compensation Altering the exposure to get either a creative effect or to override what the camera has chosen as correct.

Extension tube A tube, usually of varying thicknesses, installed in between the lens and camera, that allows a lens to focus closer than normal and provide higher image magnification.

Fill flash Direct flash used lightly only to open up or add light to darkened areas of an image.

Filter A element placed in front of the lens for either color correction or creative image making.

Flare Stray light entering the lens causing soft images and highlights. Modern lens coatings combat this phenomenon, but it can be used for creative effect on the final image.

Flash exposure compensation Increasing or decreasing the amount of flash output to get either a creative effect or to override what the camera has chosen as correct.

Front curtain synchronization In this setting, the flash fires at the beginning of the exposure.

Front light Light that falls on the front of your subject.

Gel A blend of polycarbonate and polyester resin, gels are attached to the front of the flash for color correction or color enhancement of the flash.

Go Between (GOBO) Something, such as a piece of tin foil with slices cut in it, a window frame, or another item set in between the light and subject to create an effect on the final image.

Grid Cylinder or rectangular shaped attachment with a honeycomb pattern that severely limits light spread over a small area.

High key A term associated with the overall look of an image. High Key images are usually bright in overall tone and have a white or very bright background.

High speed synchronization (HSS) In flash photography, it is the ability to use higher than normal shutter speeds to capture an image. The flash gives off multiple pulses of light before the exposure starts and ends after the shutter closes instead of one direct flash of light, eliminating the black line associated with using shutter speeds beyond the camera's maximum synchronization speed.

Highlight clipping (blinkies) Loss of detail in the highlights of an image. One of the most important aspects of exposure to learn and follow, viewed on the camera as blinking areas. When the area is blinking, detail is lost in the image; once detail is lost, it cannot be retrieved.

Histogram The exposure scale in the camera and software that shows the tonal value of blacks to whites.

Hotshoe The dedicated shoe on top of mid-range compacts and DSLRs that allows the attachment of external flashes, flash cords, radio triggers, etc.

Incident light meter Handheld light meter that measures the light hitting the subject only. Most often used in studio situations where exposure values are critical.

Inverse Square Law Property of light that states where the intensity decreases in proportion to the square of the distance from its source.

Joint Photographic Experts Group (JPEG) An image file designed to be "lossy," or to lose detail in the shadows to give files the ability to be standardized and printed anywhere in the world.

Kelvin scale The scale that attributes a number value to a color temperature without heat.

Key light Often referred to as the main light.

Lens compression Longer focal lengths, such as 200mm, compress the background from the foreground and is a direct result of angle or field of view of the lens. This is why longer length lenses are usually preferred for portrait work.

Low key A term associated with the overall look of an image. Low key images are usually dark in overall tone or have a black background.

Manual exposure Exposure setting that overrides any automation and allows full creative control.

Metering The process the camera uses to measure light to create an exposure.

Mid key A term associated with the overall look of an image. Mid key images have a middle tone and light is seen throughout the image in some form, but shadows still remain.

Off-camera flash (OCF) Taking the hotshoe flash off the camera, putting onto a lightstand, and achieving studio light quality results.

Overexposure When an image is overexposed, it is bright and loses contrast. Often attributed to high key images, it is a style that can be use creatively for black and white images.

PC socket Industry standard electrical connection used to attach radio triggers to lighting gear.

Postprocessing After capture, it is the process of final image preparation for output.

Prime lens A lens that has a set focal length and the only way to change it is to physically move forward or backward.

Program automatic Exposure setting that is handled by the camera, although it can be overridden by using exposure compensation.

RAW A proprietary file format that stores all of the file information for future manipulation. Unlike lossy files such as JPEGs, RAW images are larger as they contain all the information captured in the image. RAW files allow manipulation of white balance, exposure, and tonal adjustments before final finishing into a JPEG for output.

Rim lighting When the light comes from the rear and only silhouettes your subject.

Ring flash Lighting system that uses a circular flash tube or some modification of a small flash unit to create flat shadowless light.

Shutter priority Exposure is set by choosing a shutter speed and letting the camera choose the aperture.

Shutter synchronization The maximum speed the shutter can open or close before a black line is seen in the image. Shutters synchronize with flashes anywhere between 1/125 and 1/250 depending on the model of the camera used.

Side light Light that falls on the side of your subject.

Slow or rear curtain synchronization In this setting, the flash fires at the end of the exposure.

Snoot Cone or cylinder shaped attachment that creates a small shaft of light.

Stop A unit of exposure measurement.

Through-the-lens (TTL) The system by which light enters the lens and then hits all of the sensors in the camera so that the camera can choose all the necessary aspects concerning exposure.

Top light Light that falls on the top of your subject.

Underexposure An image that is underexposed is usually dark and becomes oversaturated. Often associated with low-key photography, underexposure can be used for certain effects.

Vignetting (fall-off) An abnormality in lens optics that causes the corners to be darkened at certain apertures. Can be added or subtracted in software for creative effect as well.

Useful web sites

PHOTOGRAPHERS

www.robertharringtonstudios.com

GEAR

B+W
www.schneideroptics.com

Canon
www.canon.com

Creative Light
www.creativelight.com

Expoimaging/Rogue
www.expoimaging.com

Lastolite
www.lastolite.com

Lee Filters
www.leefilters.com

Manfrotto
www.manfrotto.com

Matthews Grip
www.msegrip.com

Nikon
www.nikon.com

Nissin Flash
www.nissindigital.com

Olympus
www.olympus.com

Pentax
www.pentax.com

Photoflex
www.photoflex.com

Pocket Wizard
www.pocketwizard.com

Radio Popper
www.radiopopper.com

Rosco
www.rosco.com

Sigma
www.sigma.com

Sony
www.sony.com

Spinlight 360
www.spinlight360.com

Tamron
www.tamron.com

Thomas Distributing
www.thomas-distributing.com

Tiffen
www.tiffen.com

Tokina
www.tokina.com

Westcott
www.fjwestcott.com

X Rite
www.xrite.com

SOFTWARE

Adobe
www.adobe.com

Alien Skin
www.alienskin.com

Apple
www.apple.com

Corel
www.corel.com

DXO Labs
www.dxo.com

Nik Software
www.niksoftware.com

On One
www.ononesoftware.com

Phase One
www.phaseone.com

Topaz
www.topazlabs.com

ONLINE/PRINT PUBLICATIONS

Digital Photo Pro magazine
www.digitalphotopro.com

Photo District News
www.pdnonline.com

Rangefinder magazine
www.rangefinderonline.com

Shutterbug magazine
www.shutterbug.com

Photography books
www.ammonitepress.com

Black & White Photography
magazine

Outdoor Photography magazine
www.thegmcgroup.com

FORUM BASED SITES

1X
www.1x.com

500PX
www.500px.com

Flickr
www.flickr.com

Fred Miranda
www.fredmiranda.com

Meetup www.meetup.com

Rock the Shot
www.rocktheshot.com

RETAILERS

Adorama
www.adorama.com

BH Photo
www.bhphotovideo.com

Calumet Photo
www.calumetphoto.com

EP Levine
www.eplevine.com

Foto Sense
www.fotosense.co.uk

Hunt's Photo and Video
www.huntphotoandvideo.com

Mack Camera
www.mackcam.com

The Flash Centre
www.theflashcentre.com

Unique Photo
www.uniquephoto.com

Index

Acknowledgments

Thank you to the following for their assistance in supplying some of the equipment featured in this book: Nikon, Expoimaging, Canon, Orbis. com, Spinlight 360., Expoimaging, Westcott, Lastolite, Photoflex, Manfrotto, Matthews, Lumopro, Minox/Nissen, Pentax.

To Kate, Ryan, and Julia, without whom none of this would be possible. Thank you.

The models:
Kim Baldyga
Marisa Berti
Olivia Bonilla
Agnyss Bradbury
Kimberly Britt
Miranda Brooks
Cami Brown
Cori Cohen
Lindsay Comer
Alyssa Defendi
Ainsley Dicks

Stacey Gulyas
Julia Harrington
Paige Kelly
Ray Luedee
Chantel McCabe
Ashley Nihart
Julija Nikonovaite
Samantha Paternoster
Kathy Reina
Bernadette Romano
Rebecca Scalera
Linley Seip

Drea Schod
Jerry Solon
Brittany Stonisfer